Date Due

JUL 25 1983		
AUG 8 1983		
AUG 2 0 1983		
SEP 1 6 1983		
OCT 5 1984		
NOV 2 1984		
MAR 2 2 1985		
FEB 27 '90		
FEB 8 '92		

759.11
Turne

Turner, J. 86522
 Sunfield painter
: the reminiscences
of John Davenall
Turner.

2500

JUL 25 1983	FEB 8 '92 10472	
0774	FEB 2 2 '92	
AUG 8 1983		
AUG 1 0 1984		

in U.S.A.

86522

759.11 Turner, John Davenall, 1900–1980.
Turne Sunfield painter : the reminiscences of
 John Davenall Turner. Edmonton : University
 of Alberta Press, c1982.
 xxii, 128 p. : ill.

 1. Turner, John Davenall, 1900–1980.
 2. Painters - Alberta - Biography.
 I. Title.
 0888640293 1675435 NLC

6/5e

Sunfield Painter

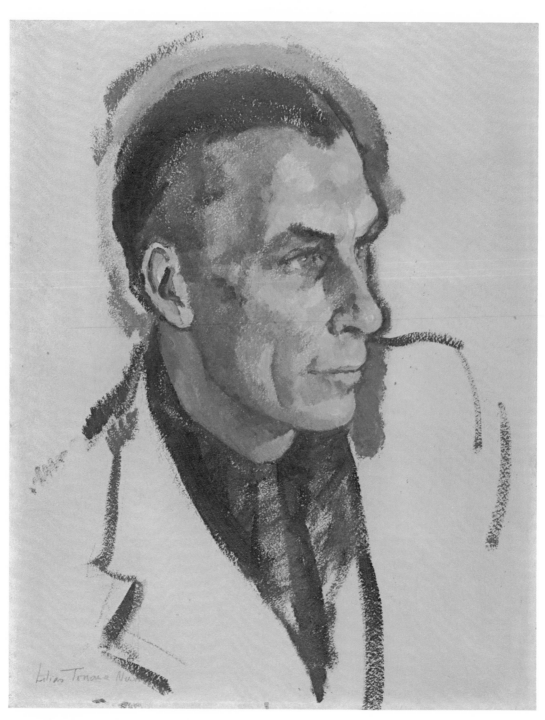

Lillias Torrance Newton, *Portrait of J.D. Turner*, 1946
20 × 16″ oil on card
Collection of Grace Turner

Sunfield Painter

The Reminiscences of John Davenall Turner

Introduction by Jon Whyte

The University of Alberta Press

First published by
The University of Alberta Press
450 Athabasca Hall
Edmonton, Alberta
Canada T6G 2E8
1982

ISBN 0–88864–029–3

Copyright © The University of Alberta Press 1982

Canadian Cataloguing in Publication Data

Turner, John Davenall, 1900–1980.
 Sunfield painter

 ISBN 0–88864–029–3

 1. Turner, John Davenall, 1900–1980.
2. Painters – Alberta – Biography. I. Title.
ND249.T87A2 1982 759.11 C82–091034–1

Typesetting by
The Typeworks
Mayne Island, B.C.

Printed by
Hignell Printing Ltd.
Winnipeg, Manitoba

Contents

Acknowledgements vii

Introduction ix

1 The Ten-Dollar Homestead 1

2 Settling In 10

3 A New Way of Life 21

4 The Second Farm 31

5 Looking for a Job 39

6 The Edmonton Plastic Display Company 45

7 Sketches for Five Dollars 59

8 Expedition to the East 68

9 Home Again 85

10 The War Years 95

11 The Art Gallery 109

Editor's Note:

The selection of paintings, by John Davenall Turner (except for the frontispiece and facing page 109, which are by Lillias Torrance Newton and Winston Elliott, respectively), is arranged to complement the artist's text, rather than by chronology, genre, geography, or any other formula. The majority of reproductions are color separated directly from the paintings to ensure color and tone quality as close to the original works as possible.

Acknowledgements

On behalf of the author, my late husband, I would like to acknowledge the University of Alberta Community Special Projects Fund and a contribution from the Royal Bank of Canada, which made the publication of this book possible.

I would also like to thank the Glenbow-Alberta Institute, the Alberta Art Foundation, the Peter Whyte Gallery, Child-Reach, and the Ranchmen's Club for photographs, transparencies, and color separations of the works reproduced in this volume.

Sunfield, Alberta Grace A. Turner
January 1982

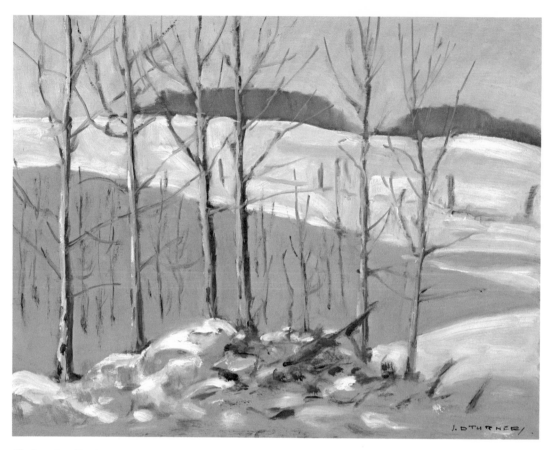

Shadows in a Ravine, 1974
10½ × 13½″ oil on wood
Collection of Dr. and Mrs. G.E. Miller

Introduction

It is a place of edges and margins; prairies abut the mountains, the horizontal vaults become vertical, the city gives way to rangeland, the last homes straggle westward as the bush accumulates. Behind him, behind the crest of the hill, is Calgary; before him is the landscape he loves, the foothills.

It is a savage day in March, scarcely warm enough to set sherds of snow jingling down south-facing slopes of the borrowpits, chilly enough to keep lizards of ice clinging to the slopes the sun cannot reach. The fields' furrows still hold snow; the land is zebra-striped. The wind flings spikes of ice as it flickers wraith-like around copses of barren aspen and down the valley of the Elbow River.

He is now an old man, but his step bears yet traces of the jauntiness it earlier expressed as he strides out in overcoat and deerstalker, in his hand a sketchbox of his own design. It is a small point of pride for him to say he has painted outdoors in every month of the year.

The land is animate, quickening, vital. The air is redolent with the acrid decay of mulch and duff the deepening frosts of autumn had cur-

tailed but which the strengthening sun of spring is reviving. Trembling catkins are the only sign of regeneration; elsewise it is straw, stubble, meagreness, and frailty. Only a fool or a passionate man could love that day of winter-scraped rawness and tempest-quickened roughness, a day of slender beauty, grimly spring. Jack Turner is enjoying himself.

Leaving the road and striking for the fields, he skitters down a slope, upending himself and skidding on his hind end. Earlier his foot had broken the carapace of ice on the borrowpit and his boot had plunged over the ankle into the muck beneath. Now he is entangled in rose thorns, endeavoring to upright himself. A foothills March sets a tough test for a nature lover's pluck. Jack is having a wonderful time.

I saw him later that day, in the afternoon after he'd napped to restore the strength the morning's exertions had almost sapped. I can see him now in many places—art galleries or museums, leisurely attending to pruning shrubs, observing birds, relaxing in his living room—but the picture I prefer is the one I have just drawn for you. Jack is no longer with us, and many who remember him well might choose other settings, but I prefer to think of Jack in knight-errantry gallantly pursuing a sketch in that almost forbidding landscape.

John Davenall Turner was a gaunt, angular, craggy, happy man, as much at ease in the genteel conversation of a public art gallery or a meeting of a historical society as he was in the wind-soughed lee of a cluster of limber pines on a hill crest. A family man at one with his wife and children, his brothers and sisters, he kept in touch with the hurly-burly of their lives, nourishing their dreams into realization, sustaining himself and them in the world's pleasures. He ventured into the margins of the world, not because the world was too much with him "late and soon," but because for him joy was everywhere abundant.

He might have sought that morning both tempest and hope, but Jack, who valued comfort and ease, spent few nights under the canopy of stars. At home with the earth, he was more at home at home. Now, relaxed and recovered from the morning's rush of passion that had drawn him from Sunfield's sanctuary to the furies of the day, Jack was sitting, civilized and gracious, in the comfort of his easy chair, familiar pipe in the ashtray beside him, his dog Suzy on the carpet at his feet, a glass of Scotch on the table, a well-loved copy of E.B. White's letters at hand, sketches by David Milne, Emily Carr, Jock MacDonald, Lawren

Harris, and H.G. Glyde on the wall behind him. In the civility he had built around himself Jack could appreciate the irony of his morning's ardor: "Ridiculous, quite ridiculous—out there in all that muck, slipping and sliding around, upending myself, all for a not very good picture, Grace wondering what could have happened when she saw the sight I was." (I didn't see the picture, so I can't tell whether his self-deprecation was part of the picaresque or not; he was probably exaggerating for the story's sake.)

Jack was the mellowest man I ever knew. He possessed a charcoal-clarified, oak-cask certainty that yielded the earthy warmth of brain-tanned buckskin, yet had the assuring strength of a plough handle cradled by working hands for two generations. He had the toughness and resilience of diamond willow, angular in grace and beautiful as the elements can shape it, in accord with wind, snow, and sun. His finest art was in living well, in seeking joy, in reaping bounty from the beauty he perceived.

Like many people who become formal the moment they sign their names, Jack was John Davenall Turner or J.D. Turner to his admirers, though he never disavowed "Jack." Formality and propriety were virtues in his canon of traits, and Grace says they were virtues he expected in others, becoming slightly distressed, for example, were her friends to address envelopes to her as "Mrs. Jack Turner." Yet to her and to their friends he was, and remained, Jack.

I first became aware of "J.D. Turner" when I was a child. The *Calgary Herald,* about 1950, published a cartoon that became a classic in Banff, one of those select items everyone pins on his bulletin board. One magnificently shaggy bear has plumped his majesty against a tree while another, earnest and forthright, suggests, "Let's go over to the dump to see the tourists!" When I was ten I thought it madcap genius. It's still rather funny, although fenced dumps no longer harbor bears, and the idea of tourists prowling around nuisance grounds is remote in today's national parks. The notion is typically Jack. He had the wrinkle to perceive the silly, as readers of his autobiography will see. Yet at the same time he could profoundly dream what could be. Often he's ironic; sometimes he's perilously self-deprecating. In the center of his autobiography he provides a quixotic account of a great migration he undertook in the middle of the Great Depression. He quits his job at a

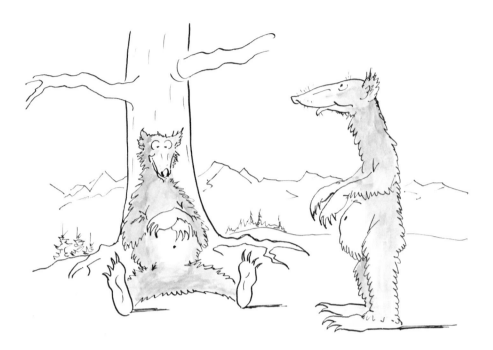

coal-yard and valorously bestrides a Rosinante—a rickety car several months shy of becoming a Bennett Buggy—and bearing his wife, their two daughters, and his sister along, he pursues an ineffable prospect of the grand. It is a sublimely funny story, and I avoid all its details here, bringing it to mind only for its mythic significance in Jack's life. Chivalry, gentility, comedy here conspire to explain best the romance of Jack Turner's life.

Autobiography is usually an act of revelation and concealment. The legerdemain of Jack's storytelling skill diverts our attention from what he suggests and lets us believe at times that Jack's life was easy. How easy it must have been to buy a dilapidated jalopy and cross Canada, paying for the trip by selling paintings for five dollars each during the depression! How easy to start a new business in an alien town with minimal capital! At the age of forty-five! Without any business experience! How easy to become a painter with a paucity of instruction! Don't believe this affable magician too frequently, but remember he had the facility of a puppy to enjoy whatever life provided.

Jack's life spanned Alberta's existence as a province. He tried to make of that coincidence a sort of significance, suggesting that he and

the province had grown up together. Well, in a way they did, of course, but I would suggest, as the autobiographer cannot, that Alberta grew up because of people like him. Alberta in 1905 could scarcely have dreamt it would be a haven for artists; it was up to the artists, like Jack, to dream that some day Alberta could deserve them. Only a few years older than the province, Jack generously overestimated the sophistication of his fellows and believed them worthy. Believing Alberta could be finer than falsefronts and cheap lithographs, Jack—with Grace's assurance and shared vision—risked security and bet his meagre bundle on his hope for a better world, and we gained more than he did on the wager.

Jack regretted his lack of formal art training. The joy of drawing he learned from his mother on the homestead, drawing on envelopes and whatever other scraps of paper he could muster. Later, in Edmonton, he dabbled in paints, both watercolors and oils, but he wanted formal instruction. As he makes clear he lacked other formal education too, yet he became a learned man, learning writing from Mark Twain and James Thurber—excellent masters—reading Tennyson's *In Memoriam* and Alexander Pope for pleasure, pursuing a knowledge of baldrics and endeavoring to learn Latin after the sale of the business.

I am in awe of the small miracles that occurred in the North-West Territories and in the early days of the prairie provinces. Young John Turner—and others like Illingworth Kerr, Annora Brown, Peter Whyte, and James McL. Nicoll—must have seen very few paintings before he became a teenager. His education in art history might have consisted of a painting or two brought from England, reproductions in magazines, and the illustrations in *Eaton's Catalogue*. How did Jack and the others perceive in that meagre fund of pictures the magic of illusion and the pleasure in picture-making that would lead them to become artists? Did it come out of a vaporous nothingness? Naturalists before Leeuwenhoek believed life generated spontaneously in stagnant pools. Fixing his microscopic lens upon pond droplets, Leeuwenhoek found them swarming with animalcula. We should be wary of assuming that the prairies were an equivalent culturally barren environment. Often enough I asked Jack—as I have asked Buck Kerr, Marion Nicoll, and Catharine Whyte—if he could explain how he and others decided to become artists—painters—when painting could scarcely have been a

career option. I hoped Jack might wrestle with the question when he began to expand this autobiography, partly because I thought a good answer could illuminate a problem of art education. Educators commonly believe that children who see enough art will grow up to appreciate it, too. How did these children of the frontier, three thousand kilometers or more from the nearest art museum, choose painting?

The answer, I suspect, is that they did not emerge from a stagnant slough. From 1870 to 1920, splendidly illustrated editions of Thackeray, Dickens, Robert Louis Stevenson, and Lewis Carroll were in many home libraries, even on the edge of civilization. Children of that era grew up with imaginations richly nourished by those cherished books. It cannot be an accident that so many of the first-generation western painters are also authors. Jack Turner's autobiography is at hand, but he also wrote trim and dapper verse. Maxwell Bates's poetry, scarcely known today, is the best poetry written in Alberta before World War II. Jim Nicoll's verse and poetry stand out in the *Alberta Poetry Annuals*. Illingworth Kerr made a living writing short stories for *Blackwood's Magazine* in the 1930s, and he later published a collection, *Gay Dogs and Dark Horses*. Annora Brown's *Old Man's Garden*, a rich anatomy of prairie botany, is followed by her autobiography, *Sketches from Life*. Belmore Browne, not a native, but assuredly a western Canadian in sensibility, wrote an account of his ascent of Mount McKinley as well as three "books for boys." In no other region of North America, I surmise, are so many painters also among the prime creators of the region's literature. Yet none of these painters is a literary painter or illustrator. They took from literature its concern with shape and form, looked about themselves and invented landscape. It's a curiosity of the forty-ninth parallel that Canadian westerners are rarely storytellers in their paintings whereas Americans were and continue to be narrative artists.

Jack, I have said, regretted his lack of formal art education. Knowing he wanted to be a painter, he painted, but he suspected knowing more techniques could have saved him considerable time. Solutions to problems he had to test by trial and error—matters of composition, underpainting to make his colors sing more, defining mass by shadow rather than line. Nothing meant more to him, Grace has told me, than the afternoon he so casually dismisses in his autobiography when H.G.

"Geo" Glyde invited Jack to accompany A.Y. Jackson and himself for an afternoon of sketching at Canmore. It assured him, albeit he might consider himself a dauber, someone he admired thought he could paint.

Western Canada by the 1930s was not an altogether lonely place. Max Bates, A.C. Leighton, the Whytes, Carl Rungius, Walter J. Phillips, and Belmore Browne lived in Alberta; and visitors like Lemoine Fitzgerald, J.E.H. MacDonald, and Lawren Harris of the Group of Seven, Americans Aldro T. Hibbard, and Leonard Richmond, and eastern painters Kenneth Forbes, Richard Jack, and Fred Brigden were in the neighborhood frequently, particularly in the Canadian Rockies. It was, if not a community of artists, a sustaining presence. Jack Turner, after he became an art dealer, was among the first to recognize the validity of the local product. He became the principal agent for W.J. Phillips, held the first exhibit and sale of Max Bates's work, and he placed their works beside the best paintings by eastern artists he could procure. There were few public art galleries and museums to recognize and endorse the western paintings, but the Turners were not inhibited in their pursuit of excellence. It must have meant a great deal to Jack's fellow artists to have an outlet for their works close to or at home. My aunt, Catharine Whyte, grew up in the Boston area, close to the grandeur of the Museum of Fine Arts and the private galleries of Newbury Street. A painter herself who had seen the withering of markets during the depression, she was very pleased by the Turners' opening their gallery in Calgary. It meant even more when Jack and Grace brought an exhibition up to Banff in June 1946, the first exhibit and sale in the town. If nowadays people lament their failure to purchase a Walter Phillips woodcut for ten dollars or an A.Y. Jackson sketch for sixty dollars, they cannot claim these gems were not available. Propped up on chairs in the United Church basement in Banff and in similar situations elsewhere, the works were taken to the broadest public the Turners could reach.

In his gallery reminiscences Jack omits one story that particularly tickled him. Shortly after he and Grace opened their doors, a young lady came in and asked if the gallery took paintings in exchange. Jack warily said he'd take a look at what she had to offer before he agreed to barter, but yet, he was interested. A day or two later she came back with a sketch, a gloomy mountain scene in a weathered frame. Jack asked her

what she might like in trade. She surveyed the gallery and selected a brighter sketch from the wall. Jack let her carry home a genuine "J.D. Turner" in trade for her A.Y. Jackson. The severe little picture by Jackson interested Jack particularly because Jackson had painted it his first trip to the Rockies in 1914 when, sponsored by the Canadian Northern Railway, he and J.W. Beatty had painted in the Jasper National Park area. Jackson recounts the trip in *A Painter's Country,* saying he had gone up the Athabaska Valley for a trip away from the rail line, and while he was up the valley the Great War broke out. The story and also the frame—it has Dr. James McCallum's name on it, and it might have once borne a Tom Thomson—made the sketch one of Jack's revered possessions. Its rareness—very few of Jackson's and Beatty's works from that summer are extant—only added to the intrigue. For the lady's sake I point out that if her J.D. Turner has not appreciated as much as the Jackson has, it is worth considerably more than she would have paid for it in 1946. The sketches people bought for five dollars when the Turners journeyed across Canada in 1935 are now worth about five hundred dollars.

Jack, Grace says, was not a believer in finding a supremely beautiful place to paint. He preferred, like A.Y., to plunk himself down just about anywhere and make a picture of what was there. I'm sure Jack exaggerated, but the observation indicates the focus of his attention: not on the spectacular or the sublime but on small pockets of beauty that exist everywhere. Anywhere was as important as everywhere else. Jack had a family to support and educate, and lacking the freedom to wander across the nation, he frequently painted near home. When he lived in Edmonton, near home could be the view across the street from where he worked on Athabaska Avenue, the copse and lake country around Wabamun, or east of the city in Elk Island. After the war and the Turners' move to Calgary, home became the foothills country west of the city—still an odyssey despite its proximity. Often enough he painted his best at Sunfield, at home, a place where storms from the mountains shape and shift the hills to the west, and where some days chinook arches seem to support the sky. Limber pines, the archetypal trees of the foothill crests, make their stands against the contending

blizzards, dessication, summer storms, the flagging clouds. Here Jack became rooted, fixed, permanent.

The limber pine could well be Jack's emblem. A tree that isolates itself from competition, it scrabbles its sustenance from scarps, stony places, hill crests, in the full force of the wind, shaped into eldritch, angular forms, its thick clumped needles holding the snow just long enough for it to become the plant's source of moisture, elegant and refined in its wildness like the bonsai the Japanese shape to reveal the thrust of elements against the stamina and persistence of life. Canadian art is unique for its portraits of trees. No other culture places such significance on trees. It is our central image. I once mentioned this to Will Townsend, the British painter. "It is no accident then, is it," he replied, "that unique among the world's national symbols is the symbol the tree on your flag." When we look at Tom Thomson's *West Wind* or Harris's *North Shore, Superior*, we see not a tree but a form of self-portrait. In *Chinook*, Jack Turner's painting reproduced on this volume's jacket, we can see a portrait he has made into a family portrait, the pines together deriving their strength in their clustering to stand against the flensing wind and make their statement under the sepulchral ceiling of the clouds formed by the warming west wind. The stalwart limber pines thrust up in a triangle of stability, vitally asserting their sustaining green against the screen of snow. The picture's strength comes from its bold, strongly monochromatic sensibility, as though the trial of winter has sapped the world's brightness, but the vaulting and dignifying chinook arch coheres and confines the image.

Grace says that Jack painted *Chinook* in difficult circumstances, long before the family moved to Sunfield, using a table on which the canvas was propped up because he had no easel, eking out the time to be a painter against his busy schedule of running the gallery, making frames in the basement, and helping the kids with their homework — in subjects he never studied. *Chinook* became a popular favorite for people who saw it, and Grace indicates he could have sold the same subject eight or ten times over had he decided to be a programmed painter.

Jack was, like that other wanderer of a small compass, a man who could say he had "travelled much in concord." Circumstance kept him at

home, but he revelled in the bounty of a small place. In Jack's paintings we feel the assurance of a man who knows the ground he walks over and who believes that an eye should enter a picture as a sojourner happens upon a place. Familiar as his places may at first seem, we can always discover much in them.

Public appreciation for Jack's painting was slow to develop. He always hung a few of his own paintings in the gallery; they sold slowly, but rapidly enough to let Jack know he wasn't wasting his time on his panels. In 1975 the Edmonton Art Gallery recognized his "definite sense of professionalism and academic sophistication" both as an artist and a dealer in fine art, calling him an "important Alberta artist" in the catalogue accompanying the exhibition of his works it presented. Jack was then seventy-five years old. The same year Canadian Art Galleries also held an exhibit and sale, and the following year held a "Special Exhibition of Recent Paintings by John D. Turner, Artist and Founder." In typical self-deprecation Jack wondered if the gallery's owners would have held the sale if he had not been "The Founder." But he enjoyed the event and relished the lionization that went with it, grinning through the opening, his first solo show in his home city.

Catharine and I dropped by Sunfield one afternoon, not long afterward. I told Jack how much I had enjoyed his shaggy bears in the *Herald* many years before.

"Ah," he said, and in a trice he had bounded up the short flight of stairs to the landing, returning a moment later with a floppy binder. He flipped to the original drawing: "There it is." It was in a section of manuscript entitled "Notes on Natural History." Preceding it was a description of mountain goats looking wonderfully agog as they stood about on peaks in a parody of a Rungius array of goats. On the next page he had typed "The Habits of the Black Bear." On the following page was the bears cartoon, captioned with the single word, "Disgusting."

"What is this?" I asked.

"These," Jack replied, are the writings of Orpheus T. Chilblain."

For the next half hour or more Jack read out his favorite passages and chuckled over his illustrations. "'The Alchemist.' That's my brother Alan. He did get the gas meter to respond to a coin he had made out of ice. Kept us warm one winter. The power company never figured it out."

OLD
HOME

"I didn't know you were a writer."

"You've never seen my sculpture?" he replied by way of *non sequitur*.

"Sculpture?" Catharine asked.

Jack escorted us down to the basement and showed us his figures. A swivel-hipped lady golfer had wound herself into a knot of consternation as she peered into the gloaming of a fairway, little realizing the ball was still on its tee. A platform-chested soprano rose to an ethereal semiquaver, which quivered a foot above her on an oscillating wire. An old cowpoke leaned against a rail. A periwigged judge glowered solemnly down from his bench.

"Have they ever been shown?" I asked.

"I made them to put in the gallery window, really," Jack said. "Had to find some way to slow people down a little. It was Stampede time, so I made the first one. Made an armature out of a coathanger, and then made a head out of the kids' plasticene, raided Grace's sewing basket for scraps of cloth, and put a costume together."

"Jack, they're marvellous," Catharine said.

"You've really had fun, haven't you?" I said.

"It's been very consoling. It's very useful having more than one art to practice. I can go out into the studio and push paint around a while. Keep it up until I'm convinced I can't paint. It doesn't take too long. Then, when it sinks in finally and inescapably, I retreat to the house, go upstairs to the typewriter and put words down on paper for a while. Gradually it becomes obvious I'm no writer. When that happens I go downstairs to the cellar, fiddle around with the sculptures for a while, until I'm convinced I'm no damn good as a sculptor, even a comic one. By then I've forgotten I can't paint, so I can go back to the studio with a clear mind and a clean conscience and paint away again for a while. Very useful."

In an alcove of the basement was a rack on which several dozen paintings were stacked. "You couldn't have seen these either," Jack said. One after another he brought them out: grotesque but highly comical paintings he'd done for a lark. Sarah Binks, the "Sweet Songstress of Saskatchewan," Michelangelo's "Adam" reaching for a cigarette instead of the hand of God, Archie Key, a long-time activist in Calgary's cultural circles, in bold profile (a version of himself that Archie

detested), and "The Newlyweds," seen in all their scrubbed aspiration on the wedding day, and then a second version of the same people in drab reality on the fiftieth wedding anniversary.

"Have they ever been shown?"

"Oh, I did them just for fun really, not to show them. We bought up some framing shop's supplies, and we inherited a grand pile of awful frames, frames I knew we could never sell. So I painted these things to go in the awful frames."

"But, Jack, they're wonderful," Catharine said. "We should find a way to show them." Thus was born the idea for the exhibition we were to call "The Artful Codger."

Exhibition curators, too frequently I feel, like to present art hermetically, sealed off from the turning and twisting of the spirit in which the artist struggles to create. Galleries make art seem a very somber business, stressing its façade of sobriety. Fortunately, Anne Ewen, then curator at the Peter Whyte Gallery, could foresee with us an exhibition that would express the multi-faceted capriciousness of Jack Turner alongside the serious J.D. Turner. We produced a small book with the same title as the exhibition, *The Artful Codger,* to introduce Jack's skills as versifier, fabulist, satirist, and wit. (The title, incidentally, was not Jack's, and it took a week or more for him to be comfortable with the idea he might conceivably be a "codger.")

Jack's involvement with the Whytes went back thirty-five years or more. Grace had met my uncle, Peter, when he had participated in a skating meet in Edmonton in 1923. After Pete's death in 1966 Jack compiled an inventory of his sketches and paintings for his estate. A year and a half later he selected, framed, and hung the exhibit of Pete's works which opened the Peter Whyte Gallery in 1968. It's a poignant pleasure, tinged with melancholy, that Jack's last show, the one which revealed his polymathic talents, was in the same gallery late in 1978.

A year and half later, in June 1980, The University of Alberta Press announced it would publish Jack's autobiography. Jack and I talked about its shape and the possibility of adding to it to provide a more rounded volume. Within two months he died. He'd made a few notes we have since incorporated into the text, but by and large his text, which he had called *Venus Rising,* stands the way he wrote it. It is charming, humorous, and warm.

Because Jack does not blow his own horn loudly, he says little about his prescience or integrity. Typically recalcitrant in his comments, he was among the first to recognize the vigor of artistic expression in western Canada. We are probably ten years shy of a substantial history of western Canadian art that will weigh, assess, and identify the roles of the native painters, the tourist visitors, the long-term residents, the interplay of artists, dealers, collectors, institutions, and corporations. Whoever undertakes to compile that history will undoubtedly discuss the Turners' energy and influence.

In 1954, shortly after Belmore Browne's death, Jack became agent for the American painter's widow and daughter. Browne is one of those anomalous painters—his son George is another, and Carl Rungius, a third—whose citizenship was American, but who did his best work in Canada or derived it from Canadian subjects. Jack could have sold the collection of some fifty paintings piece by piece, but in Eric Harvie he found a customer who desired to keep the collection together. Browne had maintained a studio in Banff for some twenty years, and although he sold his work principally in Boston, New York, and Philadelphia, Mrs. Browne and Evelyn hoped a body of his work could stay close to its subject matter. The only sad note about the sale is that Harvie talked rather grandly of preparing a Belmore Browne Room in Glenbow's Luxton Museum, a prospect which never materialized.

George Browne, Belmore's son, perhaps more of a "Canadian" than his father, was among our finest painters of game birds. Very little of George Browne's work is in public collections in Canada, but his representation in some Calgary corporate collections is due entirely to the Turners' sponsorship of his work in their gallery. George's early tragic death in a rifle accident in the Adirondacks cut his career short. Without the Turners' support few of his works would probably be extant in western Canada.

An incident that assuredly confirms the integrity of the Turners' gallery involves the Walter J. Phillips sketchbooks. The Turners were sole agent for the distinguished watercolorist and woodblock printer for twenty years. With Gladys Phillips's permission the Turners could have ransacked the sketchbooks, isolated the many small gems of full-color sketches, matted and framed them, and sold them quite easily. Recognizing the value of the sketchbooks as a model of how the artist

worked, Jack arranged for Gladys to sell them directly to Eric Harvie for the Glenbow Museum, where they are the core of the museum's Phillips collection. In suggesting they remain "of a piece," Jack forewent any commission. Students of Phillips must be thankful for Jack's good deed performed for his old friend.

If we add to the works of Walter Phillips, Belmore Browne, and George Browne the thousands of paintings by A.C. Leighton, W.L. Stevenson, Wes Irwin, Luke Lindoe, A.Y. Jackson, and others the Turners placed in southern Alberta art collections, we see the testimony of the unerring taste Grace and Jack brought to their profession.

Jack would scarcely have stood still for all this praise. He'd rather go out and paint another picture than be told he pulled off a good one. He'd rather paint than sit and be known as a painter. In a way he was like Hokusai, an "old man mad about painting."

The last time I saw him he was Jack the tinker and Jack the professional. We were at a contemporary art installation. A chute equipped with a treadmill was hustling three or four leghorns the length of a gallery; an elaborate juggernaut was supposed to be shuttling a spartan aspen back and forth beneath a Rube Goldberg confusion of full-spectrum lights, wires, hoses, spritzers, and other paraphernalia running parallel to the linear chicken coop. Guylines and pulleys had broken down; the tree cart had lurched to a halt. Jack, then eighty, ever the professional, was on his knees fiddling a rope back onto a pulley, trying to ensure the show could go on. The installation was as far from his ideals of art as it could be, but his opinion was not as important as getting the thing to work. Curiosity had drawn Jack and Grace to the event. If no one could fix the machine, then Jack would. It failed to respond to his nudging. Jack, never avant-garde himself, constantly sought what was good in the art of others. Persistently curious, he always tried to distinguish the new and the novel. The machine never did get going that day.

Always there was in him the accommodation of humor. Jack and Grace passed through town one day several months before our last visit, returning from visiting the Glydes on Pender Island, B.C. During their stay Jack had heaved up one half of a Winnipeg couch, the sort that has a space for storing the bedding. It gave him a moment of resistance, so he gave the cushion another tug. To his dismay he learned

the "resistance" was a painting by Geo, tucked away under the mattress, which had jammed the works. Jack had neatly folded the Glyde panel in half. Jack felt terrible about the damage, but the painting was beyond repair.

"What could I do?" he said. "The painting was never going to be entire again. So I offered Geo the chance to come and visit us. Then he could take whatever painting of mine he might choose and fold it in half."

The final fifteen years of Jack's life, after he and Grace sold the gallery, were the days of sunshine. Moderately comfortable, at ease in their Sunfield home with its westward prospect, settled in a gracious acreage, with a studio of ample size and "good north light," Jack could paint freely and frequently. And so he did. It was a period he used to full advantage.

But should I stop atop a hill and look to the oblique light, the persuasions of hue and form that he transformed in his paintings, I can still see a sentinel figure in the landscape—permanent, peering, and isolated, like the Inuit *inukshuks*—saying, "It is lonely here, but we are not alone."

He painted to his last morning. In the afternoon, a warm and gentle day in July, he puttered around the yard. Later, he lay down for a nap and died. It was a gentle death, completely in accord with the gentle ways of one of our few true gentlemen.

Banff, Alberta
August 1982

Jon Whyte

Chinook Sky, 1945
9 × 12″ oil on wood
Collection of Grace Turner

1 The Ten-Dollar Homestead

There is some special interest in having lived continuously in an area that within the course of less than a century has changed from a scarcely populated wilderness to an integral part of the teeming world with all its complexities, problems, and advantages. I refer to Alberta, where my family settled at about the time that it became a province in 1905, prior to which it was still part of the North-West Territories.

With the turn of the century the main influx of homestead settlers began. They were far from affluent, coming from all parts of the world by steerage passage and colonist car, many carrying in their hands their total earthly possessions.

Those who pioneered in the settlement of the province might reasonably wish to forget their early difficulties and hardships rather than feel any impulse to record them. It is not my intention here to write history. Rather, I want to trace the thread representing the common-place experiences of one individual, no doubt parallel with thousands of others, which together make up a pattern. It might be likened to taking a

handful of prairie soil for analysis to get some idea of the nature of the whole.

Unfortunately, there is a limit to the bounds of personal recollection, but aided by imagination, the first scene I remember is an English garden in the spring of 1900, the air laden with the perfume of seasonal flowers, particularly hyacinth and narcissus. I was born in January, so that makes it about right.

Lying comfortably in a perambulator on the lawn under the shade of an apple tree fragrant with blossoms and sucking my thumb, I do not recall my thoughts except that they were not fraught with any serious anxieties concerning my future destiny. From a nearby open window the comforting sounds of familiar voices could be heard, mingled with the intermittent song of a pet canary and the rattle of cups and saucers.

It was a time worthy of remembrance above all others for, apart from the felicitous circumstances I have described, I enjoyed the further benefit of occupying, even if temporarily, a unique position in the family. All other members were subservient to me and all domestic matters had to be adjusted because of me. It was a period of complete supremacy, I suppose, that we all experience at our beginning and that no future success in life could ever exceed.

The youngest in a family of five children, I had two brothers and two sisters. Alan, the eldest boy of about twelve, was away at a public school while Florence and Frank attended a local kindergarten. In the meantime, Elsie and I enjoyed the freedom of our infancy. All seemed very satisfactory. Yet, while we children were developing, my father was experiencing a rapid decline in his means of supporting us.

His early career had been in the British army where as a young man he had spent a number of years in India and Egypt. In the 1880s, gold braid and plumage marked the warrior who, mounted on a charger, pursued the recalcitrant savage across the desert sands with a sabre to consolidate the frontiers of the Empire. When he retired from the army, he married and went into business as an estate agent. But the army had not inculcated in him the business acumen civilians depend on for their highly competitive existence. So as our family grew in size, my father's fortunes diminished.

By the time I was five years old, the situation had become critical and my father was forced to consider some alternative means to provide

for our future. These circumstances coincided with inducements then widely advertised to encourage settlement in western Canada. The prospect of wide acres of land at practically no cost, freedom, and the hopeful promise of rich harvests and consequent wealth outweighed any considerations of his personal suitability to such an enterprise as farming, about which he knew nothing. Thus a drastic change in the pattern of our existence suddenly took place.

In the spring of 1905, accompanied by Alan, who willingly forsook scholarship for adventure, Father set sail for the distant North-West Territories, ending the journey at Edmonton. Then still a small settlement of mud streets and false store-fronts, Edmonton was rapidly growing up around the stockade of the old Hudson's Bay fort, and was to become the capital city of the new province of Alberta soon to be established.

To become a freehold farmer was theoretically simple; you simply filed a claim to a quarter-section of land (160 acres) and thereafter "proved-up" on it over a period of three years, which meant making certain specified improvements. If these conditions were fulfilled, subject to the adjudication of a homestead inspector, title of ownership was granted. At that time the sub-surface mineral rights were included in ownership and, in many cases, brought far greater wealth than that realized by even the most successful farm cultivation.

Soon after his arrival and a not very thorough examination of the country, the site Father chose for his ten dollars was in the midst of a vast expanse of flat prairie from which the view in all directions was the same. There were no roads, fence posts, telephone poles, or, indeed, any indication of other human existence in any form.

Here on the face of the wilderness he built a sod shack and entered into residence. The nature of this construction was such that after a time the settling down process made excavation necessary. It soon resembled the numerous gopher holes that surrounded the shack. In order to distinguish his abode from those of the gophers, Father raised a pole above it from which fluttered the banner of the Tenth Royal Hussars.

His former association with the Hussars had left a physical imprint upon him. He had the typical characteristics of a florid complexion emphasized by a large white moustache, bushy brows, and steel-grey eyes,

which combined to lend an aspect of ferocity in keeping with his erstwhile profession. These features, together with a military carriage and somewhat choleric temperament, may convey a rough portrait.

Alan filed a claim on the quarter-section adjoining Father's so that the two men could survey the total 320 acres and weave dreams of the golden harvest they expected the land to yield. In the first brief flush of enthusiasm, the area appeared to them as a fertile oasis in the broad expanse of virgin landscape.

The problem of temporary shelter having been met in the manner explained, the essential requirement of food had yet to be obtained. Provisions were purchased in considerable bulk on the occasional trips to town and consisted of non-perishable items such as flour, tea, and sugar. A popular item on their diet was flapjacks, a rugged type of pancake made principally of flour, water, and baking powder. All they required apart from these ingredients was a tin of lard, a frying pan, and a can of syrup. A truly western delicacy, flapjacks are as traditional as cowboy chaps and not unlike them in texture and flavor.

Another favorite on the homesteader's menu was a substance known as sowbelly, a sort of salted pickled pork. Sowbelly would endure under any conditions and could not be affected by changing climate, varying temperatues, or the passage of time. It was as finely embalmed as could be to render it impervious to further alteration. The customary manner of preparing it for consumption was to cut off a hunk and fry it, which did nothing more than make it hot and release a disagreeable odor.

In an attempt to vary the restricted cuisine of flapjacks and sowbelly, Alan tried to make bread. He had purchased some Royal Yeast Cakes, hard circular objects that looked like dog biscuits. Following a wholly original recipe, he added a generous quantity of yeast in order to be certain of results. He realized the mixture must be kept warm and in order to do so, because it was winter, he wrapped up the mixture in his overcoat and took it to bed with him. In the morning, Father and Alan were embraced in a series of doughy tentacles that sought every aperture of escape. With some difficulty the mess was returned to one controllable mass, but the experiment was not a success.

During those early days the population was so sparse that it was unusual to see other human beings except on the occasional trips to

town, so that when a stranger did appear he was hailed as a welcome visitor and pressed to stay as long as possible. Hospitality, though rude, was most genuine and was a result of the lonesomeness of the few inhabitants. People of various racial origins, character, education, and cultural backgrounds could find themselves upon a ground of common brotherhood, which was a good foundation for democracy in a new country.

But something usually happens to retard progress toward fraternal unity. That first winter, my father and brother had a visitor who was made welcome in accordance with the custom and style of the time, which proved a mistake. He brought others with him who remained long after he had gone. The fine supply of clothing, blankets, and other articles Father and Alan brought from England all had to be cast into a bonfire or doused with kerosene to destroy the vermin introduced by the guests.

The winter of 1905–1906 was a "soft" one with mild temperatures and little snow. The sod shack dwellers were therefore able to haul material for the construction of our new house. Each load required a round trip of about thirty-six miles and sometimes a good deal more, depending upon how far they strayed off course or got lost entirely. There were no roads and only a few landmarks to guide them.

Construction of the house progressed rapidly once the materials were on hand. The combination of the shortly anticipated arrival of the rest of us and enthusiasm for the project for its own sake spurred the two men in their undertaking. The house was built with probably more regard for artistic effect than adaptation to the rigors of the Canadian climate, but that first winter, being exceptionally mild, gave no hint of the extreme temperatures against which protection would be required.

In spite of its defects due to the builders' inexperience, the work was very creditable. It brought forth the first of many latent talents that life on a homestead quickly reveals. Under no other circumstances are versatility and resourcefulness put to a greater test.

For a period, the two-storey frame dwelling was regarded by other settlers who came to view it as far too pretentious and a waste of materials, which they thought would have been more wisely used to erect barns and other essential farm buildings. Most farmers commonly disregarded the limitations of their personal accommodation until they

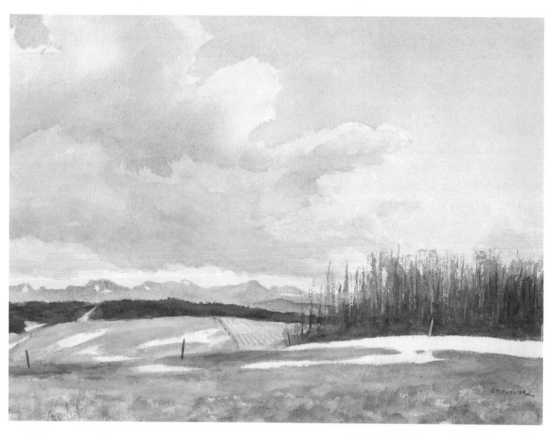

Foothills Landscape, 1978
13½ × 20″ watercolor
Collection of Grace Turner

had adequately provided for the comforts of their livestock. As settlement progress, good substantial animal housing often surrounded the original sod shack in which the owner still dwelt.

However practical such a course may have been, it did not appeal to Father. Life in the sod shack was causing a rapid deterioration of his enthusiasm for the venture in the new world. The very primitive nature of existence was almost unendurable for one of his fastidious character, to whom order and cleanliness were of prior importance. By the spring his growing discontent had ripened into a frenzy of revulsion, which future years on the homestead failed to dispel.

Back in England, my mother must have experienced very mixed feelings when the time came for her to vacate her home and accustomed surroundings to confront the uncertainties of life in a strange country and the rugged conditions I have tried to indicate.

I still have a hazy recollection of our departure; the house was empty but for a few packing cases that remained for the carters to pick up, the bare floors were littered with bits of packing straw, and our voices echoed through the empty rooms. The murky yellow light of an English spring filtered through the uncurtained windows, revealing the ghostly outlines of pictures and furniture uprooted from their resting place.

On 10 May 1906 we left Liverpool on the S.S. *Victorian* to begin the long journey. Mother had been left with the task of single-handedly making all the arrangements for packing and shipping furniture and effects, outfitting us all with clothing on a long-term basis, and at the same time coping with the normal domestic demands arising from the care of four children.

It may be imagined that having done so she must have longed for a calm voyage and a few days of relaxation. Any anticipation of such pleasure was soon shattered, however, for just as the moorings were cast, the purser handed Mother a cable from Father that consisted of only two words: "Don't come."

Whatever the circumstances that had given rise to this terse message, it was too late to comply with its instructions and at that time no means existed for correspondence between those on the high seas and others in the middle of the prairie. The intense anxiety it caused had to be borne by Mother for the entire length of the trip, added to the

normal discomforts of seasickness and other factors consequent upon the prevailing conditions of travel.

Not the least wearisome was the long journey from Montreal by rail within the confines of a colonist coach, which was especially designed for the transportation of settlers then pouring in to the country from all parts of Europe. Many family groups like our own included a number of children so that age, sex, and nationality were equally various.

Besides sleeping accommodation, the coach was equipped with a stove, which was in continual use day and night for the preparation of meals. The air was thick with diverse cooking odors, combined with stale tobacco smoke, disinfectant, orange peel, wet babies, and other smells less identifiable but equally nauseous.

A sharp contrast to the cramped week in the colonist car was experienced when we at last reached our destination, a place called Vegreville. It was dusk as we stepped from the train on to a wooden platform, hoping and expecting to be met by Father and Alan. But apart from our own forlorn little party, no one else appeared in sight.

We stood for some time as the train vanished into the gathering gloom that settled over the silent prairie, which stretched in limitless space all about us, relieved only by the few scattered buildings that comprised the town. These included a primitive hotel, livery barn, general store, Chinese laundry, and one or two other nondescript places. A few more shanties a mile or so away were known as Old Vegreville. The existence of the two sites was caused by the Grand Trunk Railway, which had laid its course a bit south of the original settlement, and the more enterprising members of the community had moved over beside the tracks.

After a period of waiting, we abandoned hope that Father and Alan would arrive. Lack of their presence caused new and greater anguish of mind to my mother as to the significance of the cable. At last we made for the hotel.

This was one of those occasions when the comforts of a hot bath, a nice cup of tea, and an aspirin could mean so much to a weary traveller. But such refreshment was not available. By the dim light of a coal-oil lamp, the entrance to the hotel revealed a few rickety chairs and several brass cuspidors as its main furnishings. A door on one side of the foyer gave way to the saloon where most of the guests were assembled. The

sounds of their uninhibited jocularity were clearly audible in all other parts of the building.

On the opposite side a similar entrance led into the dining room operated by a Chinese cook. Here were half a dozen tables covered with shiny oilcloth, each with a bottle of ketchup and a glass jar containing an assortment of knives, forks, and spoons. The only decorative effect was achieved by a number of long sticky coils hung from the ceiling designed to catch flies. As for the solace of a nice cup of tea, this took the form of lukewarm green tea and condensed milk, served in a chipped enamel cup and probably garnished with a dead fly.

The sleeping accommodation was about par with the cuisine so that the circumstances generally did not raise morale or encourage enthusiasm for our new life in the "Golden West," from which all avenues of escape were now effectually sealed off. In this unhappy situation we were forced to reconcile ourselves, not knowing for how long or what solution might be found to our predicament.

2 Settling In

The light of morning made it possible to see the expansiveness of the open prairie more easily. We realized how isolated from the world this dilapidated little village was, which added to our already dispirited condition.

Late on the afternoon following our arrival, by which time my mother must have reached the ultimate depth of despair, Father and Alan arrived. They had miscalculated the date we were expected. Relief and joy quickly replaced our former anguish, which, only when acute, renders a succeeding moment of happiness truly sublime.

The cable was explained by Father with feelings of considerable shame and regret. The conditions of life had brought him to a state of anger and disgust beyond control. Coupled with intense homesickness, these emotions may have been heightened by a bilious attack from too much sowbelly when he impulsively rode into Vegreville and dispatched his message without pausing to consider either its practicality or its effect upon Mother.

All was forgiven in the mutual sympathy for each other's sufferings. After the horses had been rested and fed, we climbed into the wagon, which was half-filled with hay and covered by a protective canvas, and headed for the homestead in true pioneer style.

At first our new house had a strong smell of green lumber and tar-paper, which were its chief ingredients, but as time passed this was mellowed by tinctures of the barnyard, wood-smoke escaping in gener-ous quantities from the stove, wet moccasins hanging up to dry, bread-making, and all other domestic flavors.

Until our furniture arrived from England we had to make do with rough improvisations. While not conducive of great comfort, the novelty of our new surroundings was sufficient to compensate tempo-rarily for its shortcomings and, apart from Father, we even managed to enjoy it.

The wide expanse of the prairie was fascinating at first. We made exploratory trips on a stone boat dragged by our horse, Old Tom, in the jerky rhythm of his steps. These excursions were often made to haul drinking water from our nearest neighbor eight miles away. We de-pended on two pot-holes known as Dad's Slough and Alan's Slough, being situated on their respective quarter-sections, for wash water. This was augmented by the occasional rain shower, drained from the roof into containers.

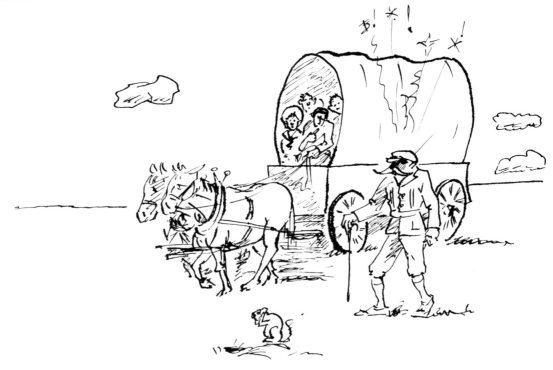

Lack of a good water supply was a serious problem because the slough water was alkaline and an uncertain source except in the spring. One of the first undertakings was therefore an attempt to establish a well, but our efforts to find water continued unsuccessfully for years. At first we thought that by merely digging a hole in the ground ten or twelve feet deep, we would strike water. At a cost of much labor this was done and a wooden casing made to line the hole, but the effort merely proved the unreliability of the theory.

It was then decided to approach the matter more scientifically, so to this end each of the seven members of the family was equipped with a forked willow stick for use as a divining rod. We all set out to see who possessed the necessary gift. Widely scattered about the premises, we seemed similarly endowed as each divining rod went down in turn. The only question to be decided was the choice of location most convenient for our well.

This being easily concluded, digging started afresh with renewed enthusiasm but diminished as the depth of the new hole increased without any indication of success. After days of heavy toil, the only moisture the new well brought was on the brows of the exhausted workers.

At this point Father sought confirmation of the promise of the divining rod and, mounting the pile of earth, he held it over the hole. It gave not the slightest tremor of motion. He presented an impressive tableau and bore an expression eloquent of his feelings.

Except for other necessary chores such as building a sod barn, hauling drinking water and wood for fuel, the unrewarding task of trying to establish a well continued until it was interrupted by the arrival of our furniture at Vegreville. A number of very large packing cases had to be moved by team and wagon in a series of journeys, each being a round trip of about thirty-two miles.

The packing cases contained a vast assortment of articles, some of them massive heirlooms of mahogany or rosewood reflecting a more gracious and elegant past rather than suiting the requirements of a homestead. However, they provided a link with happier and more prosperous times, which was a measure of compensation for my parents in facing the other privations they now shared.

The contents of the packing cases had been carefully guarded by generous quantities of straw, which was scattered immediately in front

of our house. Late one afternoon, after a very dry summer, there was a noticeable odor of smoke in the air that rapidly grew stronger and was soon visible as a haze across the landscape. Having no prior experience of prairie fire, no one was alarmed by these circumstances at first. The smoke haze thickened, and as dusk gathered a thin glow of fire was visible on the western horizon extending to the north and south in an unbroken line as far as the eye could see.

As we watched, the fire grew with unbelievable rapidity and approached with terrifying speed, swallowing up everything in its path. Here and there at intervals larger and fiercer bursts of flame shot up as the fire devoured a settler's house or haystacks, or reached a depression where longer grasses and dry willow scrub provided extra fuel. It did not take long for us to realize our peril. The first thought was the menace of the empty packing cases and straw in front of the house. All hands tried to move it as quickly as possible to a greater distance. Next, the horses were harnessed and hitched to the plow and we attempted to make a fire-guard of several furrows around the house.

This was only scant protection; the racing flames and sparks would not be stopped by anything but a very substantial width of plowing, impossible for us to accomplish owing to lack of time and light. By now, the full fury of the flames was upon us and while my eldest sister stood guard over us smaller children, Father and Mother and Alan went sternly to meet the threatening blaze, each armed with a pail of water and a wet sack to beat out the fire almost at our very doorstep. They were occupied all night and were completely exhausted from fatigue.

Their valiant efforts might have been in vain but for the help of a bachelor neighbor, who, realizing our danger and our inexperience, forsook his own modest establishment to ride at desperate speed on horseback to our rescue. He galloped straight through the flames, singeing himself and his horse in the process. With his invaluable aid, we managed to save the house from destruction, although everything else, even the sod barn, was consumed. At the time we only had two horses, put to use in the fight and protected in the area of safety. Benevolent providence, as a reward for his unselfish aid to us, spared our friend any loss. Even though his home lay in the path of the flames, the fire could not cross the greater amount of cultivated land that surrounded it.

The next day dawned to reveal a new picture, a grim and awesome sight. The prairie was blackened in every direction. Over all hung a pall of smoke only faintly revealing the pale disc of the sun. The acrid smell of burnt land polluted what had so lately been the sweet crisp autumn air.

Fortunately, this incident occurred before we had obtained additional livestock, which would have otherwise certainly been lost. Now that there was nothing left to burn, it was safe to re-erect a few makeshift buildings and proceed with acquiring some more animals. With great excitement, we waited for the return of Father and Alan and our first cow, which they had gone to purchase at some distant sale. She was a nice gentle creature and we christened her Tishla. Her chief virtue was a charming personality; as a milk producer she was not a very sound investment. Next we bought a dozen chickens of assorted breeds, representing every size and color their number would permit. The family, having no knowledge of poultry farming, felt that it would be a good idea to play their money across the board on a win, place, or show basis. There were ten hens and two roosters, and each bird had its own distinct personality and was appropriately named. James and Hildebrand, the two males, were bitter enemies. Hildebrand was a swaggering aggressive type and James was a timid soul who lived a very unhappy life. Among the lady birds, a stalwart old matron was known as Mrs. Cooper because she reminded us of our kindly old English friend, while another, an energetic bantam-sized creature, was identified as Miss Perks. She was a pushful young hussy and quite frowned upon by the other hens because of her lack of modesty and her popularity with James and Hildebrand. She was always last in when the others were upon their perches for the night, and was the subject of sidelong glances and whispered clucks by the other members of her sex in the hen coop.

The novelty of possessing animals was a delight to every member of the family at the outset, most particularly to us younger ones, to whom the animals became as individuals and close personal friends. We, of course, had no conception of them as potential business assets nor of their need for scientific care. These aspects were the concern of the elder folk, and kept them fully occupied. Farm animals are subject to a multitude of ailments and temperamental peculiarities of which the average non-farmer is not aware. To many, a horse is just a beast of

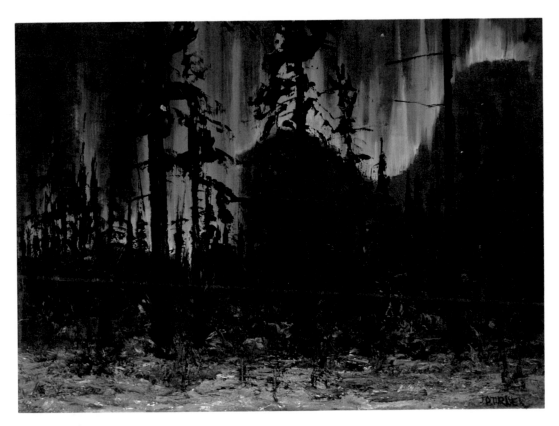

Northern Lights, 1960
24 × 30'' oil on canvas
Collection of Dr. and Mrs. G.E. Miller

burden, but he is really a highly sensitive personality, intuitively aware of the character of his master from the first instant of their contact. He can be benevolent or mean, nervous or lazy, and have just as many different dispositions as a human. The only difference is that the horse leans much more toward the virtues than we can claim to do. While he is all this, he can also be a walking encyclopedia of ailments: botts, bog spavin, hoof-rot, heaves, colic, spring-halt, and any number of others. If he hasn't got them all, he is sure to suffer from the rest before you have cured him of the few he has at first.

The greatest entertainment we enjoyed was generated by the pigs; or perhaps it was from the combination of the pigs and Father, who didn't like pigs. Our first stock in this field was an old sow named Gertrude and her five offspring, still quite young but extremely active. They were unloaded into the pen we made for them, constructed with greater regard for their comfort than their security. The result was that the five small piglets immediately escaped and went exploring in different directions. The entire family was at once recruited to capture them. It is not easy to catch a pig, each of us soon found. The spectacle of our assorted family members each hotly chasing a pig across the blackened prairie was amusing, causing Mother to abandon the effort as she collapsed with laughter. The rest of us soon gave up. Father then decided to employ a different strategy, which was to appeal to the emotional side of the piglets' nature and play upon their sympathies. He thought that if Gertrude could be made to squeal in anguish, the affectionate brood would return to her side. To this end he went to the sty and, seizing the unsuspecting Gertrude, proceeded to twist her ears vigorously. As far as the mother pig's co-operation in producing sounds of anguish, he could not have been more successful. However, her callous and unfeeling progeny showed complete indifference to her suffering and continued to enjoy their freedom.

At this point the pig business looked quite unpromising but we were saved again by the timely visit of a neighbor with greater experience and talent. This time it was in the person of a gentleman called German John, an expert pig-catcher, but not otherwise notably endowed. He was a man of remarkably short stature, and his chief characteristics were a large bushy beard and very short bow-legs, which he could move with great rapidity in the chase after his quarry. When he

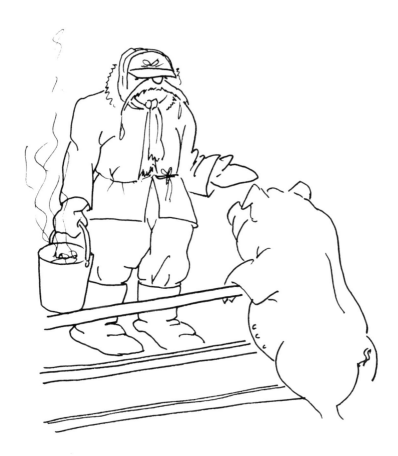

captured a pig his technique was to roll over on his back, grasp the
animal round its middle, and wait for someone to relieve him of it. In this
manner the truant pigs were returned to their abode, which in the
meantime had been roughly improved to prevent a repeated escape.

Neighbors, though few and widely scattered and representing an
interesting variety of types and nationalities, were mainly very kind and
anxious to help one another. Peter Svenson, who helped save our house
from the prairie fire, was a bachelor of many eccentricities, many vir-
tues, and a few weaknesses. Chief among the latter was his habit of
getting very drunk and remaining so for as long as he could afford. One
of his peculiarities, however, was a fear of being robbed while away on
one of his alcoholic sprees. He possessed a two-wheeled rig, which he
had made after the fashion of the Red River cart. To this he hitched his
team of oxen and, in order to protect his other belongings, he took them

along. First, he put on all his clothes, wearing one garment over the other until he could hardly move. Then he put other small possessions into the cart. His wagon, with his hayrack, his plow, and other assorted implements, was hitched to the cart. Behind this he might attach his disc or mower or both until he had a string of wheeled vehicles joined together in a train.

He would then mount his cart and, subject to the mood of the oxen, move off. Sometimes the oxen showed a reluctance to do their part and just lay down for a nap. This could occur at any point of the journey and with reasonable frequency. But Svenson was not bad-tempered or easily annoyed by such matters; he always maintained a cheerful manner. When the oxen balked and lay down in the traces, he would slowly descend from his position on the cart, calmly gather a few dry twigs, and spend some care in the preparation of a bonfire, which he would ignite in a strategic position between the animals, and then climb back on the seat of his rig and await results. They usually responded readily to this encouragement to continue and showed a much keener interest in their progress for a while. Of course, twigs were not always at hand on the treeless prairie, but Svenson was resourceful and on such occasions found other means to stimulate the action of the recumbent team. One method came from his habit of chewing tobacco. Dismounting from his box, he would stroll to the heads of the two beasts and, lifting the eyelids of each in turn, he would direct a stream of strong juice into their languid optics. He had to act with haste in returning to the driver's seat as results were even faster than the fire method. It was an amusing sight to see Svenson's rapid progress across the prairie with his weird train when, after some particularly stimulating encouragement, his oxen were in full and uncontrollable flight.

Among our other neighbors, there were two Peter Nelsons. One of them was known to be a rogue and was therefore referred to as Black Peter, while the other, more favorably regarded, was called White Peter. These became common references to the pair so that in conversation one might hear remarks such as "I was just over to Black Peter's for some oats" or "White Peter is going to thresh for me this fall." In spite of any implications, the Nelsons accepted their adopted names as a matter of course.

Another man had arrived all the way from Missouri in a wagon

pulled by a team of mules. He brought all his earthly property in that single wagon box together with his wife and their small baby. James Abraham Lincoln was a mixture of black and white both as to character and race. He had an index finger, which, due to some injury, was forever rigid and was useful for emphasizing his remarks in conversation. His mules were called Coxy and Bird, but Lincoln generally referred to the animals as "them Gawddam mules." Certainly, a more ill-favored pair of quadrupeds never existed on earth. Maimie, Lincoln's wife, was a tall lean creature who gave the impression that her bony structure was tied loosely together with bits of string. She harmonized nicely with the mules.

The local belle, Aggie Brokitz, played the ancient parlor organ in the schoolhouse for church meetings. This was in the later years, when the school had appeared as evidence of the advance of civilization. There wasn't a parson, but a lean and mildewed individual with the pretentious name of Lorenzo Tomkinson assumed the role as leader of the flock. He was an oily, snivelling person (incidentally, the same who had left the lice with Father and Alan in the sod shack). He enjoyed the opportunity of acting as the spiritual leader of the community; being almost totally illiterate and not very intelligent, his interpretation of the scriptures was about a match with Aggie's rendition of the hymns. It suited all tastes. Some found spiritual solace and others found entertainment. The only one who didn't enjoy it was Father, who made this fact audibly apparent during the only service he was ever induced to attend. He was always adept at precise criticism by use of a succinct phrase.

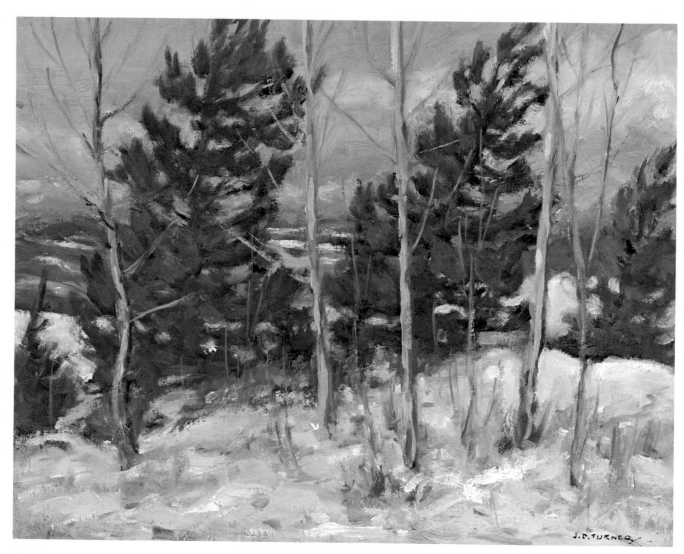

Trees in Winter, 1977
10½ × 13½″ oil on canvas board
Private Collection

3 A New Way of Life

After the fire that nearly cleaned us out that first autumn, there was only a brief spell before winter set in. It is on record that the winter of 1906–1907 was one of the longest and most severe ever experienced in western Canada. It started in September and by the following May there were still snowdrifts lying on the shaded side of building and scrub bush. Our house might as well have been made of mosquito netting. The nail heads on the inside walls all carried a long projecting point of frost. We slept in as many clothes as we possessed and under blankets augmented with anything that could serve in that capacity. In the mornings, the bed coverings were thickly coated with frost. The wood stove was stoked continuously but did little to counteract the climate, and boiling water in the kettle would change to ice in a few minutes if the fire died down; water would start to emerge from the spout and the lid in the form of frozen cones. The temperatures reached as low as $-60°F$ and created an extent of suffering by man and beast that would be hard to exaggerate.

As there was no timber near at hand for firewood, it had to be cut and hauled from the nearest copse, which was many miles away. In addition, we still had to fetch our drinking water in barrels from a neighbor. The hard ice in the barrels had to be chopped out of the containers. For the livestock, we fixed up a tin trough on a slant in which we melted snow by lighting a fire underneath. The water flowed into buckets and almost into the mouths of the animals, who always seemed thirsty whatever the weather conditions.

It was essential that efforts to make a well be continued in spite of all difficulties and discouragements. The next endeavor in this regard was to drill instead of dig, so lengths of 1½-inch pipe were purchased together with a bit and a T-piece. Then a derrick of three poles was constructed and operations commenced. The procedure was to hoist the drilling apparatus up by means of a rope attached to an arm extending from the derrick, which was then released with a thump. As it struck down, the drill was given a twist by the man holding the T-piece. At one end, the T-piece was connected by a hose through which water was pumped from a barrel by a third man. This washed out the clay and rock loosened by the drill. The barrel of water was kept in liquid state in cold weather by a galvanized iron sheet raised a foot off the ground and a burning fire underneath. Everything else was covered with ice and

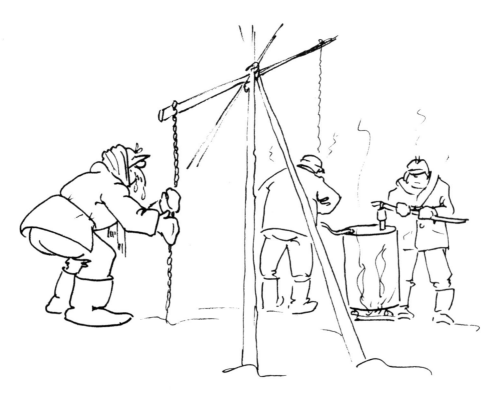

frozen mud, particularly the men. It was difficult and unpleasant work. No one realized this more fully than Father.

It was usual for the three people engaged to take turns in these various operations, but Father is customarily remembered as the one pulling the rope by which the rig was raised and released. He made a ritual of the task. Necessarily carried out in a rhythmic manner like the actions of a bell-ringer, the upward movement inflated the lungs and the downward pull expelled the deep breath, which in Father's case was laden with many maledictions. His ability to cuss in a metrical way in unison with his physical movements was a wonder to behold. He never repeated his remarks, which covered every aspect of his opinions on well-drilling, farming, and things in general. He exercised a vocabulary remarkable for its extent and imaginative arrangement and, on rare occasions when his English repertoire was exhausted, he would resort to Hindustani. His appearance also added some interest to the scene. Father protected himself against the cold by utilizing some surplus carpets brought from England to fashion crude but colorful mukluks. So that there was adequate room for extra socks and moccasins inside them, he made them of gigantic proportions. He also wore a sheepskin coat tied around his middle by a cord and an oversized muffler, further protected by a cap with earflaps. The only portion of the man left visible was his robust nose, redder than ever, and his white moustache, liberally bedecked with icicles. Thus arrayed and reciting his message of discontent in vehement cadences, he was a humorous sight, but it was a good idea for spectators to enjoy their amusement at a safe distance.

The long journeys for wood and other necessities in the depth of that winter were a real test of the courage and fortitude of the men. The snow was very deep and the drifts presented a great obstacle to the horses, who could barely struggle through the snow up to their chest. Trails were very quickly obliterated by the constant drifting, loads were upset in the uneven passage over the deep snow, and it was easy to get lost, particularly at night. The greatest safeguard against disorientation was to rely upon the horses and "give them their head," which meant to trust to their instinct to find the way home. This worked unless the horses faced a bitter wind; then they would manoeu-vre in a circular course to put their backs into the wind. Whenever Father and Alan were absent on one of these trips, we all felt a great

anxiety until they returned. At nightfall, Mother would ascend to the upper storey of the house with a stable lantern fixed to the end of long pole, which she would wave from the window as a beacon to guide the frozen and exhausted men home. The ordeal meant exposing herself to freezing temperatures, often for many hours. The silence of the snow-covered prairie would only be broken at times by the dismal howl of coyotes until, at last, the sound of clinking harness and the weird screech of the sleigh-runners would provide the long waited and welcome relief. One of us would loudly whistle the regimental call of the Tenth Royal Hussars and, if returned, the vigil ended with the short cry, "Its them!" eloquent of feelings that a more lengthy utterance could not better express. Mother would hurry from the open window to the stove to stoke the fire, heat the prepared meal and boil water in the kettle. Glad as they were to be home, the two men never entered the house until they had led the team into the barn, unharnessed and fed the horses, and made them as comfortable as possible. They finally entered in a cloud of thick vapor as the cold outside air met the comparative warmth of the kitchen. Father and Alan would be a mass of frost and icicles and we quickly had to examine them to detect frozen noses or ears. We massaged them with snow to thaw them out, which, while unpleasant, was better than the painful after-effects if neglected at the time. This was often very severe, especially in the case of badly frozen feet. After such an experience, their immediate reaction to warmth was uncontrollable drowsiness and before they had eaten the meal prepared for them, Father and Alan would fall asleep sitting at the table.

But the winter only lasted for six or seven months and then we had spring. The snow melted and the sloughs and pot-holes were filled with water; bird and beast and insect returned by some miracle of survival, seemingly impossible after such a period of refrigeration. They were not only capable of returning, but appeared more robust and plentiful than ever, particularly the mosquitoes.

As it was nearly half-way to the next harvest time before the last snow disappeared, no time was wasted in cultivating the land. In order to work in competition with the mosquitoes, tin cans containing smudges were hung on the neck-yoke of the team and on the handles of the plow to protect the man whose head was also swathed in netting. Even so, the torment of both men and animals was almost beyond en-

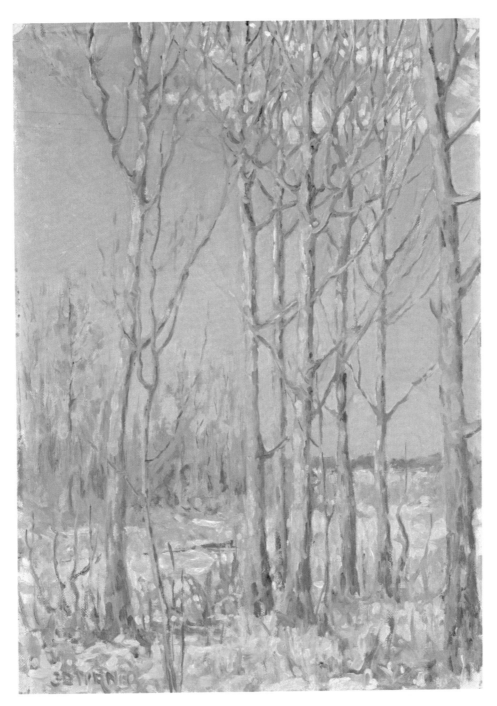

Edge of Winter, 1932
13½ × 10½″ oil on canvas
Collection of Grace Turner

durance. A larger smudge, kept burning in the yard, was the object to which all creatures stampeded when released to do so.

Prairie chickens or sharp-tailed grouse were abundant as were wild ducks so that hunting them was both profitable and pleasureable. They provided a useful addition to the menu and some sport in the intervals between work. Some farmers were not really imbued with the true spirit of sportsmanship and got their game by the simplest and least troublesome means. One of our bachelor friends would lie in the bunk in his little shanty and, when he heard the scraping sounds of prairie chickens walking about on the roof, he would pick up his .22 and fire through the roof at the spot from where the sound appeared to come. He was not very often out in his calculations. Then all he did was reach outside to pick up his breakfast on the doorstep.

When a small portion of the ground was tilled, seeding was done at the outset by hand in the primitive manner of carrying a sack of seed grain in a bag slung from the shoulder and scattering it by the handful as the sower walked up and down the area to be planted. Once this was done its further progress was watched with an eager eye. Whatever the improvement in technique as time advanced and more equipment was secured, the same anxious watch was kept. Perhaps it would be a turning point in our fortunes. A good crop would see us over the hump. Another failure could mean the end of our tether. One day would see a hopeful gleam in the eyes of the sowers as the green shoots appeared, only to change on the next day to an expression of despair when large patches of growth had vanished as a result of cutworm. Likewise, sometimes when a promising stand of grain had developed and was being admired, lowering clouds in the west gathered to cancel the moment of hope with a deluge of hail.

And so the summers passed in a mixture of optimistic hope and nerve-racking fear until the early frost came and settled the question. The reward would probably amount to a few hundred bushels of No. 2 feed, or just enough to get by the winter and tease the poor farmer into another attempt next year, or leave him in a position where threatened disaster was only deferred at the cost of hardship and suffering.

In view of the severe winter, we had been wrong in supposing that the acquisition of further livestock represented an asset. Feed was scarce and had to be bought and hauled so that the animals became an additional burden and expense instead.

26

It would be unfair to mention all these difficult and unhappy aspects of life without also taking note of those, which, however much in the minority, tended to counteract them. Fortunately, Father was gifted with a sense of humor and he engendered this quality in the others of his family. He had an extraordinary ability to mimic not only the physical and facial characteristics of people but their voices and manner of speech, and could always make everyone laugh when such a tonic was most needed. He also read aloud with great skill from a good selection of books he had brought from England, and this was one of the entertaining and educational ways our evenings were spent. While listening to his reading, we children discovered a leaning toward artistic expression and would all sit around the table with pencils and paper drawing by the light of the kerosene lamp. Mother had to search for old letters or envelopes that provided blank areas on which we could exercise our embryo talents. Those were delightful moments; we scribbled and listened to Father as he brought to life the characters in whatever book he was reading.

Apart from such amusement indoors, there was ice on Dad's Slough. Once we shovelled mountains of snow from the surface, we had a place to skate. Skis made under the direction of a Scandinavian neighbor also gave us amusement and healthy exercise in the open. There were also occasional informal dances or parties arranged among the farmers; all and sundry participated enthusiastically, however far the journey to or from the scene of the event, and usually such frolics lasted all night.

Another annual source of variety and excitement was the arrival of the threshing gang in the fall. Tom Thorsen was the owner of the outfit in partnership with Otto Lund, a big raw-boned Swede with eyes so badly crossed one could never tell in which direction he was looking. They had an old J.I. Case steam-engine and an antiquated threshing machine that they took from one farm to another with their motley crew.

Although the threshing gang did nothing to cause anyone particular pleasure by their presence, they broke the monotony of life and created temporary excitement. Whatever the quality of the harvest, the coming of the threshing gang was a highlight, which, to children at least, seemed to justify all the effort necessary to reach such a climax. Preparations would commence days before their arrival and consisted mainly in

27

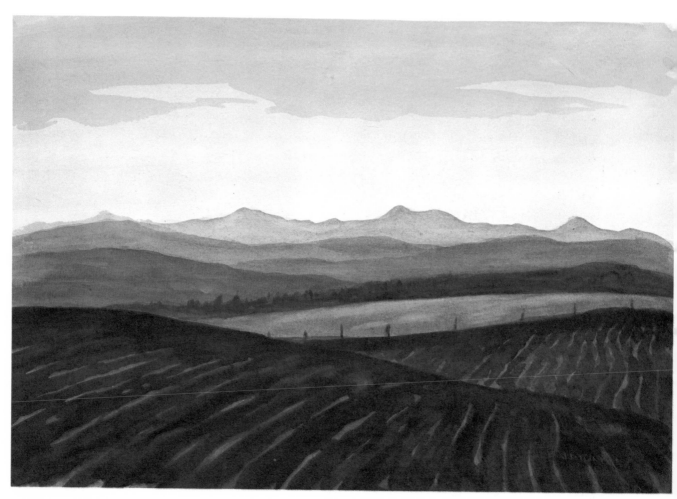

Ploughed Field, 1970
10 × 14″ watercolor
Peter Whyte Foundation

cooking and laying up a sufficient store of food. It is unlikely that anyone could challenge the gastric capacity of the thresherman. The womenfolk helped each other. If the Nelsons were having the gang first, Mother and the rest of the neighbor women would be there to help Mrs. Nelson, bringing with them their extra pots and pans and dishes. When it was our turn they would all come over to help Mother, and so the heavy task of catering was accomplished by co-operation of all the women throughout the district.

Another diversion we enjoyed was the occasional trip to town for supplies, by wagon in summer and either by sleigh or cutter in the winter. Nothing beats a light cutter and a team of lively horses to kick up the snow in your face as they race along. A nice big stone, heated in the oven before starting and placed under the wraps to keep your feet warm, provided comfort and complete enjoyment, especially when coupled with the rare delight of a visit to civilization—such as it was.

Apart from the business to be transacted, the visit to town afforded the opportunity for a brief moment of socializing with other members of the widely scattered community, and a chance to compare notes on crop conditions, the price of hogs, and other matters of mutual interest. The general store was the chief meeting place and the local saloon was also not without its atmosphere of communal interest.

The general store of those days had a particular character fast disappearing even in the remote parts of the country where modern chain-store merchandising is rapidly finding its way. We pay for the charm and the intimacy of the past with the increased efficiency of the present and in all aspects of life one wonders if progress and improvement are at all synonymous. A flat-faced building with a wide porch or platform in front of it and a row of hitching rails, where there are now parking meters, was the usual type of country store premises. The porch was invariably occupied with miscellaneous individuals gossiping, whittling, and spitting tobacco juice in pleasant idleness. In winter they sat inside around the heater, which occupied the centre of the floor, and carried on in the same way. There was a certain kind of smell peculiar to general stores of this kind. If you were to become sightless and subsequently placed in such surroundings, it would not be hard to identify your whereabouts if you had ever before been exposed to that queer

aroma. Presumably it was created by the jumble of assorted merchandise scattered about on counters and shelves and hanging from the ceiling. The endless inventory included such items as horse collars, ladies' ready-to-wear, dried apple rings, neck yokes, cowbells, coal-oil, yard goods, cheese, oilcloth, pickaxes and tools of all sorts, sheepskin coats, and so on. You could find gopher traps among the dishes or lingerie among the pitchforks and stable lanterns. It was a sort of scrambled department store and the lack of order was part of its character and appeal, as well as its function as a centre of social intercourse and discussion.

Out in the backyard, there were barrels of oil, threshing machines, plows, and so forth. The storekeeper was usually the agent for some implement company and while it kept him fairly busy, he frequently had time to act as local Justice of the Peace, undertaker, and was also probably the mayor. He needed a full line of work as practically all his business was on a deferred payment basis and income from any enterprise hinged upon the outcome of the crops or other uncertain prospects that only providence could control. He also had to compete with *Eaton's Catalogue*.

4 The Second Farm

While physical hardships were the common lot of early homesteaders, unfortunately they were not the only obstacle to progress, being augmented in our case by financial difficulties. The slender resources upon which the venture had been undertaken were soon exhausted while any prospect of revenue from it appeared to diminish. It gave rise to deep concern and to the remark, made at intervals by either Mother or Father, "We must write to Gasquet."

This was the name of a London solicitor who was the custodian of some mysterious funds held in trust for us children. He was occasionally urged to pay out fractional amounts in advance of our reaching the required aged of twenty-one when told that, otherwise, it was unlikely that any of us would survive to that age to become beneficiaries.

When it ultimately became obvious that our original homestead site would never provide the means of survival due to lack of water, timber, tillable soil, and other defects, with Gasquet's help we were enabled to abandon the premises and secure another quarter-section with these

essentials. The new place was a beautiful tract of land, well timbered, with an abundant water supply, and good soil, and well cultivated. It also included some sound buildings.

The dwelling house on the new farm was a substantial log building nestled comfortably in a grove of trees. In the undergrowth there lived many wild partridges, a variety of small birds of the songster species, as well as squirrels. It was fascinating new territory to explore, but the first time I heard the partridges drumming, I fled from the woods in terror at the unaccustomed sound. There had been few animals on the old farm except prairie chickens, ducks, gophers, and coyotes, and these became too familiar to hold further interest. One creature emitted an eerie sound at dusk and defied all our efforts to identify it for a long time. It was simply known to us as the "Oompah Bird" for lack of more positive information. We eventually found that it was a bittern, booming as it sat sorrowing among the tall weeds that surrounded Dad's Slough.

I should mention that the small animals on the new farm were not all confined to the woods but some were even more populous in the house and of a much less desirable nature. The bed bugs, except when the house was warm and quiet at night, spent most of their time in the cracks of the logs. Having loafed all day, they came out at night fresh and hungry to appease their appetites upon the human occupants. Combatting them provided me with a not only useful but entertaining task. I had a spray gun filled with some sort of liquid disagreeable to bugs and one of Mother's old-fashioned flat-irons. When I squirted the liquid into the cracks, the slumbering bugs awakened in dismay and came rushing out in evident consternation, whereupon I added to their sense of ill-treatment by squashing them with the iron. Before long the survivors realized that such persecution was intolerable and they left for new localities where hygiene was less practiced. There were many promising sites among the neighbors where doubtless the displaced bugs found a haven among relatives.

For some reason, Father and I formed an advance party in moving to the new place. On our journey by team and buggy, the horses bolted. The harness broke, allowing the horses to escape and the tongue of the buggy to fall, causing the vehicle to come to an abrupt stop, pitching us both over the dashboard into the position just vacated by the horses. Unfortunately, we landed in what had been a patch of scrub willow

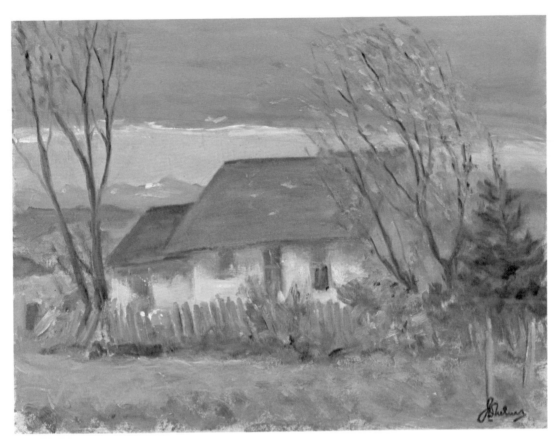

McFarlane's House, 1968
10½ × 13½'' oil on card
Collection of Grace Turner

recently burnt off by prairie fire, leaving only short sharp stumps. It was like being thrown onto an upturned drag harrow and we were painfully hurt by the spikes sticking into various parts of our anatomy. The fact that the accident occurred very near the end of our journey was the only good thing about it and we limped the rest of the way in an appro-priately downcast mood. It took a couple of days to find the horses; they were finally located in a clump of trees in which the harness had become tangled and held them captive.

Apart from that somewhat inauspicious beginning, we enjoyed life on the new homestead and were able to make definite headway from then on with the advantage of past experience and improved facilities. Instead of flat treeless prairie, we were surrounded by rolling hills, trees, and small creeks. There were plenty of wild berries, raspberries, saskatoons, and gooseberries, and we had many fine times gathering them in the pleasant country we now found ourselves, even though the actual distance from our original homestead was not very great.

Being the youngest member of the family, I escaped a great many of the arduous tasks that employed the others and I always found plenty of enjoyable diversions. I was, however, supposed to be the poultry boss. I used to hitch up a proud and gaily plumed rooster to a small home-made sled and watch him pull it in jerky steps with evident realization that sport was being made of his dignity. Another trick was to place a very undersized hen on the handle of the cream separator and then swing it backward and forward, causing the bird to perform a ridiculous gesture; as the handle swung foward its neck would be drawn back and its tail pressed hard down, and with the opposite movement its neck would shoot out as the tail flew up. The alternate expression of consternation and extreme anxiety that I discerned on the poor creature's face gave me the greatest fun.

We kept a number of beautiful white ducks, purely as pets, and they all had fancy names of the most absurd kind. A very great favorite, a little fluffy duckling called Peekeeokee, would have grown into a fine fellow but for the intervention of tragedy. Peekeeokee felt the need of affection perhaps more than the others because he had no mother, having been born in an incubator with a lot of chickens. He followed one of us to the door of the house as was his custom, and on this occasion

34

decided to sit down on the doorstep to wait. Unfortunately, the first person to come out stepped on poor Peekeeokee, bringing his short career to an end. The family was plunged into deep sorrow since he was particularly special among the ducks who were all very dear to us.

There is a great joy in close acquaintance with a duck or a pig or even a chicken, or any creature with which you live in certain intimacy, as we did with our livestock. The animals soon assumed identities as individuals and we felt an almost equal sympathy for them as we did for people. Due to this sensibility, farming was in some aspects very repel-lent, for we had to slaughter beasts as part of the business. This was never accomplished without the greatest anguish even though the skills necessary to the task were completely mastered and killing was carried out with merciful suddenness.

With hogs, a stunning blow was dealt and the throat of the unfor-tunate victim was cut immediately and very thoroughly. Within an instant, the animal was immersed in scalding water and then scraped with sharp knives to remove the bristle. It was then strung up on block and tackle. A full-length incision was made from tail to snout and the internal mechanisms were removed. The carcass was subsequently divided into proper sections according to standard butchering specifi-cations. The same general procedure was adopted for cattle except that the victim was shot with a .22 at a point just above and between the eyes and then strung up, after which it was skinned instead of scraped. In either case, the process was carried out without delay and with deft skill, even though it was abhorrent. There was no waste either of time or of the deceased. What was not edible, such as hoofs and hides, still had some market value. The animals could have had whatever consola-tion there was in knowing that they were thoroughly mourned, and that a sense of bereavement settled heavily upon those who consumed its remains. Whether the menu featured cold tongue or oxtail soup, it served as a sad reminder of a departed friend.

To offset the unpleasant tasks there were always others that afforded particular delight. One was haymaking, beginning with the purring sound of the mower at work in some low lying ground where the lush grass grew. The sound came in changing cadences on the wind, which also bore the sweet fragrance of the newly cut grass. Raking it

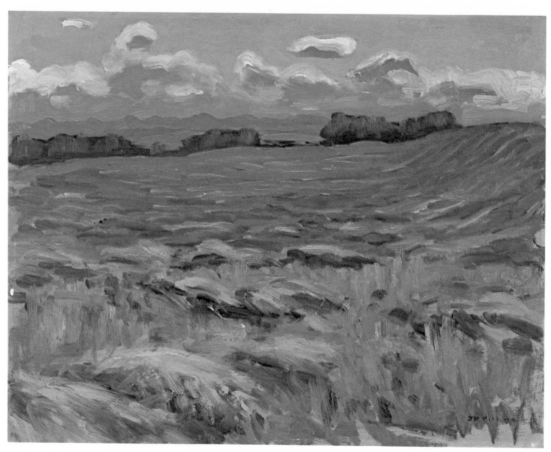

Stubble Field, 1963
10½ × 13½″ oil on wood
Collection of Grace Turner

into cocks, subsequently loading them into wagon racks, and then stacking were all gay tasks carried out during the most pleasant time of the year, and usually combined with impromptu picnics in the fields. There were many happy rides back and forth, either high up on top of the loose soft hay, or returning for another load in the empty wagon, jolting over the rough ground behind the trotting team.

Another job that could be classed as recreation came in the brisk fall days when it was usual to stock up on the winter supply of firewood. We journeyed on the open running gear of the wagon to the woods when everything about was painted in the gay colors of autumn. Soon the ringing strokes of the axe would echo through the still and otherwise silent woods. While the trees were being cut, those of us not so employed would be busy with tin pails gathering the wild berries. We would have a picnic with the pleasant smell of wood-smoke nearby and a pervading feeling of happiness and exhilaration, which is natural to the combination of youth and health and the beauty of the earth. Finally, the wagon piled with logs to keep us warm all winter, we would ride home in the dusk, singing lustily.

With new advantages and experience gained at heavy cost, a point had been reached where success was promised at last. By now we had a complete understanding of all aspects of farming, animal husbandry, crop cultivation, dairying, and the thousand varied subjects the general terms "farming" embraces. No occupation calls for greater resourcefulness or universal talent. To shoe horses, repair machinery, to be veterinarian to sick animals, to combat pests, and butcher livestock for food are but a few of the skills required. Having gained full proficiency in all these and with natural conditions suitable to their profitable exercise, it seemed that at last the efforts of the past would be rewarded. The senior members of the family had spent years of almost epic heroism for which prosperity was surely their due.

But the hard-won victory that appeared within our grasp now exacted the last and heaviest toll. The struggle it had entailed resulted in my mother's illness and death. Farming was at an end. In 1912 we sold out and moved to Edmonton.

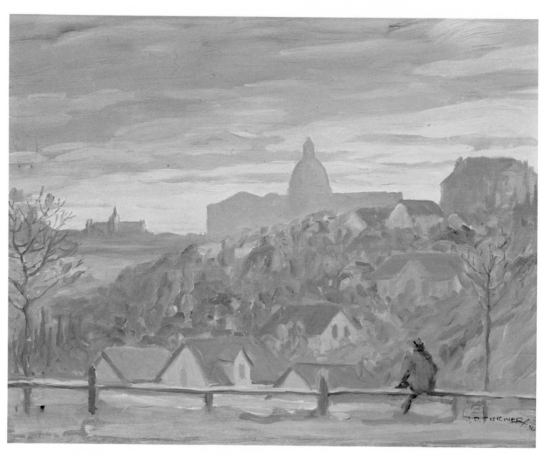

Edmonton Parliament Buildings, 1936
9 × 12″ oil on canvas board
Alberta Art Foundation

5 Looking for a Job

Readjustment to urban life was not easy. The process of job hunting, hat in hand, was painful after the freedom and self-reliance of the homestead. Now that the complexion of life was radically altered, some new means of existence had to be found, which excluded the peculiar skills we had acquired on the farm. Jobs of one kind or another were found but the two years prior to the First World War do not intrigue my memory and are perhaps best forgotten.

After many vicissitudes in an effort to re-establish himself, Father secured the office of Sergeant-at-Arms to the Alberta Legislature, and by some means obtained the sanction of the authorities to take up his residence in the massive domed edifice in which it is housed. We thereafter referred to him as "Our father which art in the Parliament Buildings."

Until we arrived in Edmonton I had never seen the inside of a school, but my mother had been conscientious. She had given us regular lessons on the homestead and encouraged our neighbors' children to

join. Entering school for the first time, I found it even more distasteful than the average child who had perhaps experienced less of the joys of freedom. I was twelve years old but as no parental pressure was exerted by my father to remain, I left almost immediately.

The Tenth St. Faith's Troop of Boy Scouts occupied part of my time. The Reverend Canon Boyd, the incumbent of St. Faith's, conducted a mission house. He sent forth his missioners to cover a wide field and bring much needed spiritual guidance to the growing rural population.

The Boy Scouts somehow acquired bugles and drums and we marched about the streets making loud and disagreeable noises and enjoying ourselves, doubtless to the distress of the residents. On one occasion we attended a summer camp on the farm of Mrs. Irene Parlby at Alix for a week. Mrs. Parlby was, incidentally, Alberta's first woman parliamentarian. Joined by the local Scout troop, we slept in the loft of her barn and made life wretched for the two unfortunate clergymen who were our leaders.

Included in our groups were two freckled-faced kids named Millen. The youngest Millen later became a member of the Royal Canadian Mounted Police and will long be remembered as the Mountie who lost his life in 1932 at the hands of Albert Johnson, the Mad Trapper of Rat River, who after a long chase in bitterly cold weather, was eventually hunted down and killed. This incident recalls the name of another man who took a prominent part in the hunt, W.R. (Wop) May, with whom I subsequently worked for some years.

The most beneficial result of my association with the Boy Scouts arose from one of our members who worked as an office boy and got me a similar job with the law firm of Short, Cross, and Biggar. There I might have risen to the eminence of Sir Joseph Porter, K.C.B., the ruler of the King's navy in *H.M.S. Pinafore,* had I applied myself to my duties with equal diligence. The prelude to my downfall was that I preferred to lean out of the window of our second-storey chambers and aim metal paper-clips propelled by an elastic band at passers-by in the the street below. My career with that firm was terminated when I made some facetious remark to the effect that Mr. Short was cross because he wasn't bigger. He was, indeed, of very short stature, but he was also

40

Mayor of Edmonton and when my indiscreet remark reached his ears, he naturally resented this reflection on his dignity by the office boy.

My employment with Short, Cross, and Biggar at an end, I soon found a similar position with Rutherford, Jamieson, and Grant. Mr. Rutherford had been Alberta's first premier, so that I felt in even more distinguished association than before. I continued happily for some time until, for no doubt good reasons, Mr. Grant decided that I was unsuited to the legal profession.

The truancy regulations must have been very lax at that time to have enabled me to be employed, especially by law firms, at the age of thirteen. When I was occasionally asked by a truant officer why I was not in school, I referred him to my father, who seemed to satisfy their inquiries. Now unemployed, I used my enforced leisure to try and improve my education, however, not by attendance at school but by fairly diligent homework assisted by textbooks obtained from the public library. By this time we were approaching the end of the second year of the 1914–18 war. My brother Frank, already a member of the local militia, had left with the first troops from Edmonton and was now in France. Alan had been repeatedly rejected on medical grounds and I

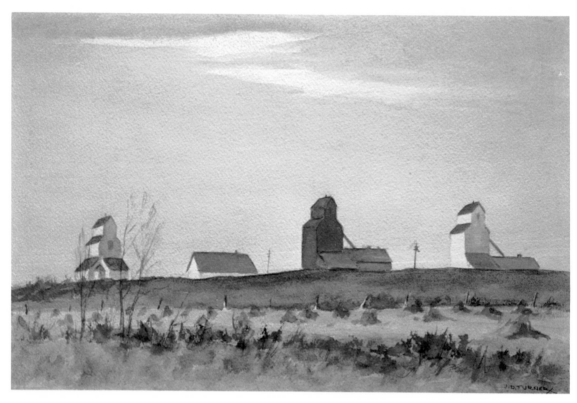

Grain Elevators at Balzac, 1970
15 × 23″ watercolor
Collection of Joyce Davenall Turner

was too young to join. The time was approaching, however, when I would be old enough, and with this in mind I was prompted to study. Subject to the required educational standard, I could join the Royal Navy Air Service as a cadet at the age of seventeen and a half.

After a period of concentration on home study I finally entered the Technical High School, where I hoped to obtain the official grade standing for my purpose. I explained to Mr. Hilton, the principal, that I had been privately taught. He put me in Grade 10 to test my knowledge, which I was happy to find was about equal to my fellow students who had spent the weary years covering the preceding grades.

Graduation to Grade 11 the next term gave me the required standing called for by the Royal Naval Air Service so I immediately quit school, applied, and was accepted. By dint of persistence, Alan also finally gained admission and we were together. This was not until the spring of 1918, however, so that our military careers were both brief and nondescript. This was compensated by Frank, who had returned in the meantime with the scars of war and a medal for distinguished conduct.

On arrival at the Recruits Depot, Jessie Ketchum School, Toronto, I felt very ill. The cause was diagnosed as scarlet fever, so I was sent to an isolation hospital for six weeks. I gave the disease to Alan, thus further delaying our warlike intentions. My progress was again hindered when on release from hospital I was told that I was to be a photographer posted to Camp Borden. Protesting that I knew nothing about photography did not seem to impress the authorities, and so I went to Camp Borden, where for several weeks I tried to learn how to load gun cameras. I continued to complain but I had no experience as to the right procedure in my circumstance. It was no use sharing my sorrows with my immediate companions; only when I attempted to confide in an irate sergeant-major after he had retired for the night was I paraded before the commanding officer, who said he would look into the matter.

Before his inquiries were answered we were all informed that the Royal Naval Air Service and the Royal Flying Corps were about to be amalgamated into the Royal Air Force, and that if anyone objected to serving in the new unified service, they could apply for discharge, which I immediately did. No sooner had I taken this action than I was called to the orderly room and told that due to a mix-up at headquarters, I had

been wrongly identified and was to proceed on immediate posting to the Cadet Wing at Long Branch where air crew training commenced.

Optimistic that my difficulties were now over, I rejoined Alan at the Cadet Wing where we spent our time learning ceremonial drill under the critical instruction of some non-commissioned officers borrowed from the Guards Brigade, who were very outspoken in their comments about us. While this instruction seemed irrelevant to our object of becoming airmen, we assumed that ultimately such we should become.

Happy in this anticipation, all seemed favorable to my hopes until I was again called to the orderly room and told that my discharge had arrived. After a great deal of explanation to convince them that now I no longer desired it, I finally succeeded in having it cancelled.

But progress was soon again arrested when the entire camp was placed under quarantine due to the outbreak of the influenza epidemic. For weeks we continued the tiresome exercises we had begun, living in leaky tents while the rain poured down, and both suffering the effects of the current disease yet too afraid of further loss of time to report sick.

The brief happiness we experienced when the quarantine was finally lifted and we moved on to the School of Aeronautics was short-lived by the announcement that the war was over.

6 The Edmonton Plastic Display Company

In the intervening time the family had become rather more scattered. Father was living in an apartment and, of my sisters, Florence had married and Elsie was working in Mexico City.

Having made our contributions with varying success to the war effort, my two brothers and I took up residence together in Edmonton in a strange little house situated on the back of a lot on 107 Street. An annex to a rooming-house, our abode had been converted for dwelling purposes from what had formerly been a large garage. In the limited space we set up the old furniture that had been hauled across the prairie in 1906. The acquisition of several dogs and cats added to the congestion.

Alan and Frank had always possessed a strong predilection for art and I strove to emulate them. By now we all shared a full sense of dedication to the subject. In addition to their skill in the field of graphic art, my two brothers developed an enthusiasm for sculpture. While they were busy making gelatine molds and spreading a deep layer of plaster of

Paris over the house, I amused myself with paint and brushed at the piano, which was my easel. Although the result of these activities was a state of considerable domestic disorder, we were absorbed and happy with our artistic pursuits.

In the early 1920s, the development of artistic interests in Edmonton was begun by Mrs. Bowman, who almost single-handedly laid the foundation of the present Edmonton Art Gallery. She packed, unpacked, and hung exhibitions, working tirelessly to stimulate public interest in art. Among the first exhibitions Mrs. Bowman arranged was one of the Group of Seven. Nothing could have been better calculated to stir the enthusiasm of the aspiring artist. When I took my father to see the paintings, it was almost sacreligious to hear him describe the "Tangled Garden" by J.E.H. MacDonald as reminiscent of a bit of Brussels carpet. But he was not attuned to the vigor of the new Canadian School and his tastes, unfortunately, favored the sentimental or anecdotal works of Victorian England.

In Edmonton at that time there existed only one artist in professional practice. An elderly Scot, William Johnston had established his studio in the Tegler Block. I sought him out in the hope of securing help in my struggle toward the light. Johnston was a gentle and delightful man, but unfortunately schooled in the tradition of which the Group of Seven was the antithesis. His method of teaching was to have his students copy Sutton Palmer illustrations out of a book called *Beautiful Britain*. While attractive in depicting the quiet rural scenes of England, these exercises were not likely to lead to masterful paintings of the more primitive and elemental Canadian landscape popularized by the Group of Seven. Several of us under Johnston's tuition decided that the formation of our own group might be helpful and so we founded the Edmonton Art Club, which still exists today.

Something about the things my brothers and I did and the way we lived seemed to attract people with a taste for the unusual. We did not seek acquaintances but somehow they developed and in all instances our friends were characterized by some quality setting them apart from the normal. They ranged from tender youth to extreme old age and they came to see us when the spirit moved them, without waiting for invitation, so that we usually entertained in completely chaotic surroundings, which, indeed, appears to have been part of the attraction; the other

might have been our very good home brew at a time when prohibition was in force.

Frank was very adept in the art of illuminating and whenever a dignitary like the then Prince of Wales or Governor-General was about to make an official visit to Edmonton, he was called upon by both city and provincial authorities to prepare an address. In the midst of the mess and confusion of our little house, he produced documents that were superlatively beautiful, combining fine lettering and decorative embellishment.

While we seriously pursued art in various forms, it was not without the object of making it pay. This was, and always has been, the most difficult aspect of the matter. In order to further the commercial possibilities of our efforts, we decided to form the Edmonton Plastic Display Company. All we needed was to print a business card. Our kitchen was the main office and manufacturing plant, with branches all over the rest of the house. Apart from the name, our card indicated that we could undertake any assignment in the field of visual art. We flung this reckless challenge abroad in the hope that we should find large profits from those who chose to accept it.

One of our first assignments was to manufacture hundreds of plaster figures of the comic strip character, Jiggs. We also had to paint them. The order was placed by the Benevolent and Protective Order of Elks in connection with a large convention they were holding and had to be delivered by a certain not-too-distant date.

With great zeal we started to execute the first order placed with the new firm. Before a week was out it was nearly impossible to get into the house for the Jiggses, which infested every nook and cranny of the place upstairs and down. In addition, there were remnants of broken Jiggses and casts and all the mess their creation had entailed. A large barrel of plaster of Paris occupied the centre of the kitchen floor and every utensil of whatever nature, including those jointly used for cooking, had been pressed into the service of the production. Even the dogs and cats were covered with a coat of white dust.

This was only a hint of greater havoc yet to come. The next stage was to paint the figures—mostly purple. It was a truly horrifying experience to see everything and everybody you love turn purple and stay that way for weeks on end. Particularly depressing was that they were

set against a background of ruin and desolation colored with the same ghastly hue. Such was the condition resulting from our initial order, completed to the satisfaction of the customer and delivered on the specified date. It marked what has subsequently become known as our Purple Period.

One of our most frequent visitors was the policeman whose beat included our neighborhood. He did not call upon official business, but rather for a chat and a snack. During his visits, the horse he rode on his rounds was tethered in the long weeds that grew in luxuriant abundance all around the premises. Harry the policeman gave us our best recipe for home-made beer. He introduced us to a product called Cream of Malt and Hops, which came in a tin and looked like molasses and was advertised as being particularly beneficial for nursing mothers. It did not give any information as to dosage or how it should be administered, but, under the capable guidance of the policeman, our method was roughly as follows: empty the contents of tin into a five-gallon earthenware crock and add lukewarm water until about four-fifths full; throw in a couple of yeast cakes and some sugar and cover; allow to stand for several days in a warm place until thoroughly fermented; clear by use of isinglass or egg white; bottle and allow to mature as long as possible. This was usually not very long.

This product of the Edmonton Plastic Display Company was one of its most successful, although it was not distributed commercially; it was merely employed to cement goodwill and was chargeable as an expense to our Advertising and Public Relations account.

Harry was not only of service in providing instruction for making this excellent beverage, but he happily furnished us with empty bottles in which to store it. During prohibition, many enterprising souls engaged in the operation of illicit stills and produced a wide variety of alcoholic poisons of one sort or another for commercial gain. They were constantly being raided and their stocks and equipment seized, which meant that a good supply of bottles was always on hand at the police station. F. W. Woolworth & Co. thoughtfully kept a stock of bottle caps and a tool for fitting them.

The only really difficult part of the process was filling the bottles. Done by a system of gravity, it entailed carrying the vat upstairs to the landing and using a long strip of small rubber hose to convey the liquid

Athabaska Avenue, Edmonton, 1934
25¼ × 18″ watercolor
Alberta Art Foundation

from the vat to the rows of bottles waiting ready on the kitchen floor. The idea was to fill one, pinch the hose to stop the flow until it was aimed into the next bottle, and so on. There was more skill required to do this than one would imagine, and the usual result of filling a dozen or two bottles was to have an equal quantity of brew in puddles and streams all over the floor.

When the bottles were all full, the capping operation followed. The Woolworth's tool was placed over the cap and then struck a sharp blow with a hammer. As might be expected, in the majority of instances this resulted in shattering the bottle and allowing its contents to join the puddles and streams, which soon began to assume the proportions of lakes and rivers.

Alan, of course, was chief brewmaster and, having inherited from Father the valuable attribute of eloquence when annoyed, he found this occupation one that called forth his highest expressive capabilities. He made remarks about Mr. Woolworth and his capping tool that would have deeply offended that eminent and respected man if they had ever reached his ears.

On occasions when such activity was in progress, we were often interrupted by the appearance of a visitor or two. It might be Sylvia Eger, the middle-aged spinster who wrote poetry. A tall thin person of great charm and kindliness, Sylvia had a personality that acted as a magnet to admirers both human and otherwise. Sylvia's charm lay not in her appearance, for she was not handsome and inclined to careless choice of clothing, which she wore untidily. Her hair usually hung in wisps and her lean middle-aged form moved in a loose and ungainly way. But her innate good nature and kindness disguised these other defects. She, of course, had no children and but one dog, yet there was invariably a following of both at her heels. She was not a person of any particular education and her poetry was bad. Most of it stemmed from her earlier recollections of a romance that had not matured satisfactorily. Whatever the course of her experiences in life, they had not deprived her of a sound sense of humor and an open mind, and she was not easily shocked. Sylvia was a fair sample of our acquaintances: they liked beer and conversation and had the same tastes.

Besides Harry the policeman and Sylvia the poet, we were frequently visited by the young Warren brothers, whose interests leaned

toward the occult. Then there was Sir Cecil Denny, a very old man who always had an enormous scarf tied about his neck, whatever the weather and who also liked to drink beer and eat apples. He was the Provincial Archivist and was assigned to amass details of the early history of the province since he had been one of the original members of the North-West Mounted Police and had participated in some of the most exciting phases of early settlement. Then in their declining years, Geoffrey and Lil Taylor were perhaps the most interesting couple. In the flower of youth, they had been thespians in the company of Sir John Martin Harvey and others of his ilk, outstanding in their presentation of tragedian roles. These two seedy remnants of a colorful past never failed to lend the histrionic touch to their every word and gesture. When they called upon us, they did not just come in, they entered. For Geoffrey and Lil, to open the door was more like raising the curtain on the final and most moving act of a play. They stood upon the threshold in a carefully studied tableau expressive of some mood that lay too deep for tears. After a few glasses of the nursing mother's elixir produced by the Edmonton Plastic Display Company, their repertoire seemed to improve and if shown sufficient hospitality, they could be encouraged to the highest achievements of dramatic art. At least, such it seemed to them and probably to their audience at the moment. While Geoffrey fell increasingly under the influence of the tragic muse, Lil was inclined on the opposite course. She revived the memory of some of the more gay aspects of the theatre and regaled us with gems from music hall favorites, both song and story, the choices of which were not such as one might expect from an elderly lady.

Among the jobs done by the Edmonton Plastic Display Company was repairing mannequins used in shop windows. At that time many mannequins were made of wax, and in their original condition included quite charming replicas of blondes and brunettes rendered in careful imitation of Miss Universe so far as beauty of face and figure were concerned. However, when the sun shone upon the shop windows in which they stood adorned in the latest fashion, the smiling lips drooped into a hideous leer, the eyes slid down the cheeks in varying angles, and the chins became elongated in a grotesque and witchlike manner. There was no limit to the ways in which these transformations replaced smirking beauty with Frankensteinian horror.

It was no small undertaking to restore their former pulchritude once they had spent a week-end under the glare of the summer sun in Eaton's windows. The technique of reclamation was complex. The figures had to be melted and remodelled and their complexions returned to such as would make the producers of toilet soap envious. A powder called ox-blood was used extensively and was kneaded into the semi-molten wax. Hair-dos had to be restyled and, in some cases, when the tresses had slid into the position of side whiskers, new heads of hair were welded into the waxen craniums.

These difficult assignments were carried out on the kitchen table in our small bachelor home. The baker, a French Canadian named Armand Tougas, was reasonably accustomed to the domestic oddities of the customers on his route and was even beginning to accept our strange habits with complacency. But on the day he had his first introduction to our waxwork industry he got the fright of his life. Throwing open the door to offer his basketful of loaves for selection as was his habit, he beheld Alan in the apparent act of committing a horrid crime. Armand saw the recumbent figure of a young woman upon the table, her golden hair tumbling to the floor, her eyes and features terribly distorted, and Alan grasping her by the throat with hands covered in scarlet powder, which Armand assumed to be her life blood! The same sanguine evidence was splattered liberally all about the floor and the scene of horror was eloquently reflected in Armand's ashen face and bulging eyes. He was about to run off for help but was quickly reassured that he had not witnessed a homicide, but one of the processes of art.

Our evenings were frequently enlivened by the presence of mixed company. Mr. Symes, cheered by the applause and the influences of home brew, played upon the piano and sang ditties culled from musical comedy favorites. Mr. Stillman, whose Pooh-Bah-like dignity never forsook him, gave exercise to his vocal talents in more serious vein. I think he had a secret belief that the New York Metropolitan Opera Company suffered a great loss in not having discovered him. While the music played, others would be huddled in a deep discussion of the arts or some subject of profound philosophic import, while yet another group was probably sharing anecdotes of questionable delicacy between whispers and laughter.

Meanwhile, the animals took advantage of our various abstractions. The cat might produce a litter in Geoffrey Taylor's lap, or the dog would

eat some new gelatine molds required for an important production by the business.

On one occasion our guests included several lady friends of Frank's (and he had a great many). They were requested to place their coats and hats on the bed in the first room at the top of the stairs. In anticipation, we had previously left two of our most bedraggled waxwork ladies, prior to repair, reclining with their heads on the pillows as naturally as possible. The visiting girls had to switch on the light, as part of our plan, and we waited with eagerness for their startled response. Screams of horror even more intense than we had hoped for was our reward. It took more effort to calm them than in the case of Armand Tougas.

It would be difficult to catalogue all the jobs undertaken by the Edmonton Plastic Display Company during its brief and unprofitable lifetime, but what was lacking in volume and profit was made up in variety. On one occasion we were called upon by a furrier whose wax models we had repaired to prepare a backdrop for his window in connection with an autumn sale. It was a large window; the area to be occupied by our backdrop was about eight feet high by fifteen feet long.

Undaunted, we set to work. First we constructed a wooden frame of the same dimensions and then stretched duck cloth over it on which to execute our "Muriel," as we called it. This taxed our studio facilities to the limit, but by having one end in the corner of the living-room and the other in the opposite corner of the dining-room, then canted at an angle of forty-five degrees, it could still be pushed out the kitchen door when completed. The backdrop was extremely inconvenient to live with so we worked industriously to complete it as soon as possible.

Armed with brushes and pots of bright color, Alan started in the living-room corner as I started in the dining-room and we worked toward each other. No prior design had been prepared or any decision as to compositional arrangements. The order was for an autumn landscape and we both approached the task falling on pure inspiration to be our guide. We seemed unstintingly endowed with creativity as we splashed our scarlet and orange pigments lavishly upon the canvas. With progress of the work, the spirit soared within us and we became obsessed with the creative urge to do justice to the glory of the passing season.

Finally we met under the aperture between the two rooms and paused to compare our respective interpretation of nature's lovliest mood. Perhaps "mood" was the only point of resemblance; with respect

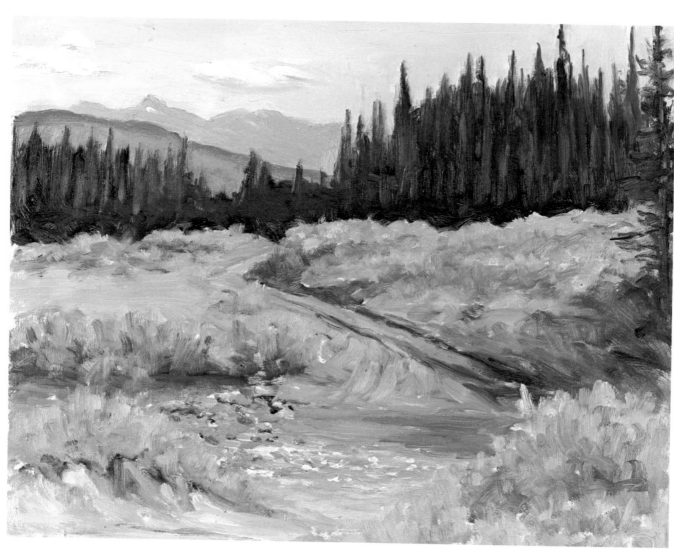

Fallentimber Creek, 1978
10½ × 13½″ oil on canvas board
Private Collection

to topography there was no relationship at all. Mine was a mountainous country of pine and rocks while Alan's was the quiet pastoral scene of meadow and pond and flat hazy distance with gracefully situated aspens. The foot or so between us represented a problem in reconciliation that would have confounded the most learned geographer. It was too late, however, to reconstruct our individual approach to the subject, so we painted a road down the centre leading into the mysterious infinity of the horizon and let it go at that.

Our next task was to get rid of it so we could go on living in the house. Alan bravely undertook delivery of the canvas. Having gotten it out the kitchen door, he grasped the supporting frame in such a way that the unwieldy object was, in effect, on his back, projecting a long way both in front and behind him. On the windy afternoon he set off to carry it several blocks to the furrier's shop, he was taken considerably off course in the process. How he navigated to his destination still remains a mystery, but having done so, the furrier expressed utmost satisfaction with what was probably the worst artistic creation ever perpetrated.

On occasion the Edmonton Plastic Display Company was recruited in the interests of science. The Medical Department of the University of Alberta required the production of exact scale models of the human epiglottis and other related portions of the anatomy to illustrate the various conditions of the thyroid glands, both normal and otherwise. This assignment was accepted by Alan with great enthusiasm, for the matter represented a welcome challenge of skill and intellect. It required a very thorough research prior to executing the work so that he became almost an authority on this very complex aspect of medical science. After a considerable time, we had a house full of the most realistic extractions from the human throat in natural colors indicating small veins and the windpipe, muscles, and cartilage. It was just as if the rather unpleasant-looking portions might have been recently removed from the body. They were highly successful and were received by the authorities with many compliments upon their accuracy. The several slightly imperfect copies left over were sometimes used as a centre ornament on the dining-room table when entertaining friends at dinner.

This gave rise to another remarkable request from the same source. There was an unfortunate man afflicted with a disease that was consid-

ered sufficiently unusual to keep a visible record of the symptoms—certain swellings on the torso—comprehended only by the medical men concerned with the case. His hope of survival from the ailment was entirely forlorn. Before the patient succumbed to this disease, Alan was asked to make a plaster cast of his torso and reproduce it for future reference and study. The poor man's willingness to submit to the discomforts occasioned by this process for the benefit of science, added to his already great suffering, is a tribute to his character. The replica of the man's torso was faithfully reproduced, but Alan decided that a head and arms should be added. The head was modelled and accomplished without difficulty, but for some reason Alan decided to cast his own arms and hands instead of modelling them. This feat taxed his skill to the utmost, yet he succeeded in his purpose.

On another occasion, entering into the realms of art for art's sake, Alan made a very fine bust of a senior statesman but found no takers for his non-commercial product. Being of hollow plaster, the dignified national leader proved to be an excellent refrigerator and was made the receptacle of milk and butter in warm weather.

My brothers also undertook a contract to model various objects from butter for the annual Fair and Exhibition. This meant spending a considerable number of days in a large refrigerated storage where the material for this work was contained. Although uncomfortable, they produced many intricate images in butter that provided subsequent interest to visitors at the Fair. Otherwise, Alan and Frank received meagre reward and severe colds from the project.

By this time our various industrial enterprises had left their mark upon our surroundings: the purple of the first job and the bright hues of autumn from the fur sale backdrop and the ox-blood of the waxwork phase. I made an effort to erase these stains by painting the walls with a mixture of lampblack and white calcimine, which resulted in a dismal grey. This effect appealed to our friends, the Warren brothers, as just the right atmosphere for developing their interest in the occult. They persuaded us to participate in a number of spiritualistic seances, adding variety to our normal forms of entertainment.

The electric light globe was encased in green material for the purpose adding still further to the depressing aspect of my slate-grey walls. It also gave the sitters unhealthy-looking green complexions. The sur-

roundings did not encourage any visitation from the probably more desirable realms above, even though we sat in a silent and respectful circle in conscientious hope. The only person who may have found pleasure in the exercise was a young lady, the medium, who liked holding hands with the younger Mr. Warren.

The experiment was at last terminated due to the nervous state of one of the ladies, who found the eerie proceedings rather frightening. The deep silence was suddenly shattered by the abrupt entry of Harry the policeman, who walked in without knocking as was his custom to indulge in a bottle of home brew. The nervous lady nearly went into orbit from her chair.

The Edmonton Plastic Display Company, although it entailed both varied and interesting work, was not profitable. Eventually Frank and I found employment in other fields and left Alan to cope with any future demands that might arise and to act as housekeeper, a department in which his skill never shone very brightly. Ultimately he, too, decided upon an alternative occupation. At the same time, he left us to share an apartment with Father that afforded some improvement in the amenities of life. This decision was brought about by the fact that Frank and I had both decided to get married.

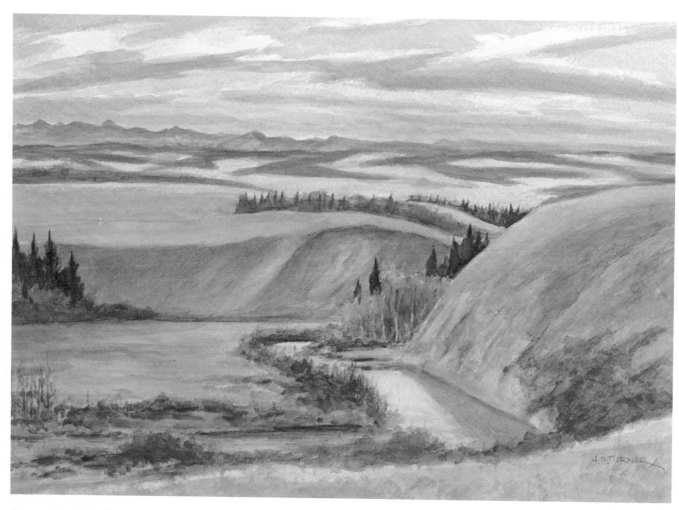

Jumping Pound Creek, 1976
13¼ × 20¼'' watercolor
Collection of Grace Turner

7 Sketches for Five Dollars

An event of importance above all others was my marriage to Grace Robertson on 15 August 1928. My conscience still arises accusingly to remind me that I assumed this great responsibility without means to justify such a step. In fact, I had to borrow five dollars from my bride to take us home from our honeymoon, a period at Banff.

We travelled to Banff over the gravel roads in Alan's ancient Chevrolet with an average of two flat tires per day. It was kind of him to lend it to us for the two weeks, but car problems together with the restrictions placed upon us by my lack of finances were but a foretaste of the rough seas through which we were destined to sail together in the future. That we navigated them successfully from the outset was due mainly to Grace's fortitude and wisdom, the main stabilizing factors throughout. Without them we should have inevitably landed on the rocks.

At the time of our marriage, I was employed in the local agency of a cash register company. It was a fairly congenial occupation. The staff

consisted of four people: the agent, a senior salesman, the repair me-
chanic, and myself. The repairman was W.R. (Wop) May of war ace
and bush pilot fame.

Following the example of the agent, there was an atmosphere of
carefree indifference to rigid routine or discipline and our relationship
with one another was that of close and intimate friends. We all shared
the view that pleasure should be on equal footing with business and the
agency was merely required to meet or if possible exceed a monthly
sales quota.

After a few years nothing appeared to threaten the security of our
future, which on the contrary seemed to point toward ever-widening
horizons of prosperity. Our family had increased to include a daughter,
Joyce, with a further addition soon expected. Based on these favorable
conditions, we committed ourselves to the purchase of a house. In all re-
spects, the situation appeared most satisfactory.

Then the depression came and altered our lives with dramatic sud-
denness. Businesses collapsed everywhere, and caused a rapid decline
in the sale of cash registers. Being the junior member of the staff, my job
ended on a week's notice and, like thousands of others, I was faced with
the meagre prospect of alternative employment as the ranks of the job-
less swelled.

It was a case of instant destitution because payments on our house
had precluded any other savings. The day I was fired coincided with the
birth of our second daughter, Jean. Sadly, I had unpleasant tidings for
my wife in the hospital.

To meet the immediate need arising from the emergency created by
these circumstances, art again became a slender resource. I had contin-
ued my interest in painting and had accumulated a number of small oil
sketches, which I decided to try and peddle at five dollars each. Appro-
priately, I borrowed a bicycle for this purpose and on it made my
rounds, encumbered by the somewhat bulky portfolio I had made to
contain the sketches. My victims were mostly professional men—
doctors, dentists, and lawyers—who were exceedingly kind in patroniz-
ing my efforts.

Selling sketches was a very painful and embarrassing occupation
that I was glad to exchange when any opportunity for employment
arose. Such occasions were scarce and of extremely varied character.

Once I was a temporary postman during the Christmas rush, which I enjoyed because it provided a sense of playing Santa Claus. With greetings and parcels to deliver, I was met with welcoming smiles by everyone on my walk, with the exception of one or two unfriendly dogs. The most amusing aspect of this job arose from the strange coincidence of being allotted to an area that included my own house. It was fun to walk up my own steps and ring the bell and hand my wife letters and greeting cards addressed to myself.

Art in one form or another served a useful purpose when all else failed. On one occasion I was asked by a printer to draw a series of pen and ink sketches of wild animals to illustrate a brochure. Long afterward I looked at the reproductions of those drawings and was pleased to realize that they were quite good and far better than I could have produced at a later stage in my life. It seemed to indicate that when in desperate need, kind providence had endowed me, at least temporarily, with the necessary talent to do something that I would normally be incapable of doing.

Similarly, at another time when we were at a point of greater need, we went for a walk on a beautiful day to seek solace in nature, and I made a sketch that sold to the University of Alberta for ten dollars. This was accomplished through the kindness of Dr. Corbett, then Head of the Department of Extension. The only drawback to this transaction was the delay in collecting the ten dollars. I had to submit five copies of

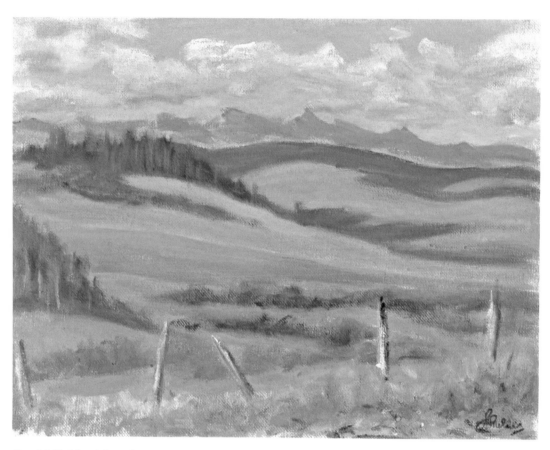

Ranchfields Near Maycroft, 1976
10½ × 13½″ oil on canvas board
Collection of Grace Turner

an invoice to be processed through their accounting records before payment could be made.

There were many instances of rescue by some providential incident, which may have been the reason for our subsequent and continuing faith that provided the only basis for some of our later hare-brained enterprises. Between divers occupations we managed to survive for a considerable length of time, even though by a narrow margin. In the meantime we always scrutinized the "Help Wanted" columns in the newspapers. These represented a very slender hope; for each vacancy there was always a line-up of applicants. Yet it was from this source that our salvation finally came.

The job called for a bookkeeper for a coal-mine and, in spite of knowing little about bookkeeping and less about coal-mining, I was the successful applicant. Obviously this was not due to my qualifications but because of some peculiar rapport between Jim Mann, the boss, and myself when we met as complete strangers. I have every reason to remember him with gratitude for selecting me and for his kindness during difficult years for both of us.

The pay was seventy-five dollars a month and free coal, which in these more affluent times may not be considered much for six days a week and overtime, but to those in our circumstances, it represented a positive bonanza.

The office of the Marcus Coal Company was a dingy little shack on the corner of a back street in what was generally referred to as the wholesale district. It occupied a corner of the lot that was otherwise filled with piles of coal-dust, bits of broken machinery, and puddles of dirty water. The area was marked by warehouses and freight sheds among which ran a network of spur tracks.

One or two boxcars of coal were always spotted on the spur behind our office from whence deliveries of the coal were made by trucks. The mine itself, where the boxcars were loaded, was outside the city at Clover Bar.

Most of the coal was delivered to families on relief and paid with public funds, the average price being $3.75 per ton. Deliveries were made to all parts of the city by truckers who, besides the arduous work of loading and unloading, were often required to make long trips. As most of this activity was during the winter months, their difficulties

were frequently complicated by getting stuck in the snow or the break-down of their truck.

The Marcus Coal Company was clinging to existence by a thread and it was always questionable whether we would be able to meet the pay-roll. But Jim Mann kept it going, not because of any likelihood of profit, but more for the sake of providing employment for as many and as long as possible.

Both from the physical outlook and the general circumstances, my job did not provide an environment calculated to cheer the spirit, yet some degree of light-heartedness was maintained to which the drivers contributed rough good humor. They would hurl verbal insults at each other in an apparent effort to see who could excel in the art of imagina-tive vituperation. These colorful exchanges were, paradoxically, indica-tive of mutual goodwill and comradely feeling. They were scrupulous in seeing that each got his fair share of the small amount to be earned by their labors and went to each other's assistance immediately when difficulties arose. The truckers exemplified one favorable facet of the depression: it brought to light latent qualities of human sympathy and kindness, which arose from sharing common hardships, that in times of greater prosperity seem less apparent.

Even in the unpromising atmosphere of the coal company office, I found an outlet for artistic expression by creating an advertising calendar of twelve ridiculous sketches, each of which illustrated some aspect of the coal business described in a verse. The jingles were con-tributed by my brother Alan who had a knack for rhyming. The follow-ing is an example:

For deliveries right on the dot,
And for COAL that burns brightly and hot,
I've long wished for in vain,
Said cross Mrs Pain.
Said her friend, Mrs Jones "And why not?"

"If for fuel you are caught in a fix
MARCUS SERVICE the universe licks.
Which will quickly be shown
If you'll pick up your 'phone
And call TWENTY-FOUR-SIXTY-ONE-SIX."

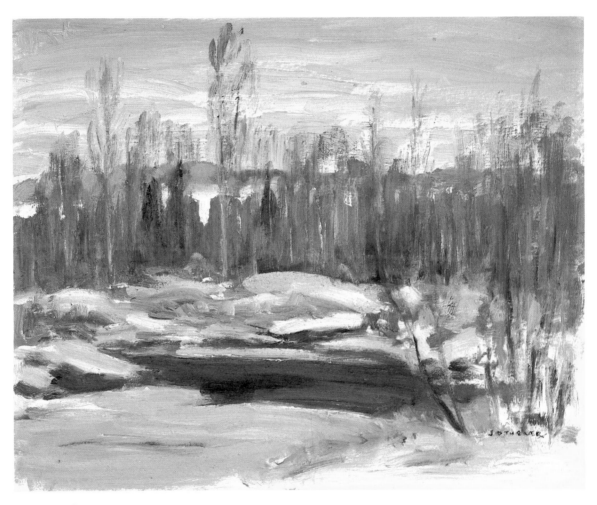

Alberta Landscape, 1972
8 × 10″ oil on wood
Collection of Grace Turner

Much as the job meant to us, life was circumscribed by the limitations of our small income. We were young and I still clung to my aspiration to become an artist. After a couple of years or more, the prospect of ever realizing such ambitions seemed increasingly distant, so we gave serious thought to the possibility of change before it was too late.

At about the middle of the winter season of 1934–35 I proposed to Jim Mann that during the following spring and summer, when the coal trade was at its lowest ebb, he might save the expense of my salary if I took a leave of absence. I explained that we had decided to go East in the hope that I might find some occupation that would enable me to study art on the side. If, however, I was unsuccessful, I would return to his employment again in the fall. To this proposition Jim readily agreed. My leave of absence would commence on the following 15 May.

Having thus committed ourselves to this rough plan, the next and greatest problem was to implement it. We had no savings and the difficulty in undertaking such a project was obvious. Our first decision was to make no further attempt to retain prospective ownership of our house. There seemed little hope of catching up with payments in arrears and accumulated taxes.

We decided to inform our mortgage holder that we would relinquish all claim to our house as of 15 May but meanwhile occupy it without further payment in satisfaction of the small equity we had. The money diverted from house payments was put aside to purchase a car for our eastward journey.

We had less than six months to gather all the necessary resources for the proposed adventure. At the top of the list was an automobile and a small tent. All our provisions for the trip had to be bought out of our small income over and above normal current living expenses in the meantime.

By the time the date of our departure drew near we had secured the tent and had saved $125 for the purchase of the car. One of the coal company truck drivers, who also operated a small filling station on the eastern edge of town, said he knew a man who had a fine car for sale at that price, so we handed the money over to him to negotiate a deal on our behalf.

We waited in keen anticipation for Jim Letcher, our agent, to deliver the car and optimistically built his recommendation of it into a

mental vision of a shiny luxurious vehicle that increased in splendor as our unrestrained imaginations played. When he arrived we beheld in the harsh light of reality an object of the most dilapidated appearance. Its scarred and battered body was surmounted by a leatherette roof that had been coated with tar to delay decay. There was a sway-backed look about it, which suggested that it had been subjected to burdens greater than it had strength to bear. The interior upholstery was worn and faded and smelled of dust and mold combined with gasoline fumes, and the whole thing rested on four wooden spoked paintless wheels.

Jim suggested a demonstration drive. On pressing the starter, the machine shook violently as though in the grip of palsy. Dense smoke and fumes issued from beneath the floor boards accompanied by sounds from the engine making conversation inaudible. As it moved forward, the spokes of the ancient wheels creaked in their loose sockets, but once in high gear these various sounds blended into one at first frightening amal-gamation to which we grew accustomed in time.

Our next acquisition was a trailer. In some tall weeds down the street I had noticed an old running-gear of about the same vintage as our car and negotiated to purchase it for six dollars. My father-in-law, a fine carpenter, built a box for it so that now we had a serviceable means of carrying our luggage and spare tire. We also mounted an old tin trunk on the rear fender for additional carrying capacity.

Perhaps the most optimistic feature of our plans was the idea that the day-to-day expenses of our travels would be covered by the sale of my sketches en route. I had accumulated a number of oils, about 8 × 10″ or smaller, which I put into white cardboard mounts with a sheet of tissue over them to add artistic finish. The sketches certainly required all the embellishment I could provide to make up for their other obvious shortcomings. The price was, as formerly, fixed at five dollars each.

8 Expedition to the East

The 15th of May arrived and I said farewell to my associates at the coal office in the fervent hope that this would be final emancipation from the drab existence of the past few years. All that remained before our journey were a few last-minute details. The car was given a final tune-up and servicing, the furniture put into storage, and our baggage packed.

My sister Elsie had returned from Mexico in the meantime, where, as a result of the stock market crash, she had lost her many years' savings and had been unable to find employment. At the last moment she elected to join our expedition in the same hope that the more populous East might provide opportunities she could not find locally.

By the time the last incidental expenses had been met in preparation, including the tune-up, our cash reserves were exhausted. We sold a stove and a phonograph and Elsie contributed her last fifty dollars to the kitty. We faced the long journey, a proposed trip of some two thousand miles in a derelict car with worn-out tires on gravelled roads, and without such essentials as a lifting jack or tire pump.

The only assets we possessed in abundance, very necessary in the circumstances, were faith and a remarkable trust in our respective guardian angels, who served us diligently even at the cost of what must have been considerable overtime on their part.

Too late now to retreat from the undertaking, whatever hazards it presented had to be accepted. The actual date of departure was 17 May 1935. The two little girls, Joyce and Jean, now four and five and half years old, were put in the back seat with Auntie Elsie and we set out to call on our various friends and relations to bid them adieu.

This proved to be a long operation. At each call we were delayed with offers of refreshment and helpful advice until the day wore on toward evening. With the passing hours the weather, already threatening, continued to deteriorate. Our final call was on the edge of the city and the rough gravelled road leading toward Calgary. As we said our last goodbyes, the gathering dusk of evening was heightened by lowering storm clouds, which finally broke upon us with lightning and thunder and a deluge of rain. Under these rather unpromising conditions we were at last on our way. Metaphorically speaking, we had hitched our wagon to a star. We came back three months later hitched to a farm truck loaded with hogs, but that is by the by.

As we proceeded onward in the increasing darkness, the tarred roof soon provided evidence of its inadequacy; heavy rain fell upon us in uncomfortable trickles.

At top speed of about forty miles per hour, we at last reached our first stopping place, Wetaskiwin, where we decided to call a halt in the hope that the climate would improve by the following day. We drove to the auto camp, but found on arrival that it was not yet open for the season. But the man in charge, feeling sympathy for our unhappy plight, told us we could use the central kitchen building, which was boarded up and contained a couple of large stoves and several picnic tables. We soon had a fire in one of the stoves and Grace prepared a hot meal. The picnic tables served us for beds.

The first leg of the journey was thus marked without great comfort or reassurance, yet not without some redeeming aspects of good luck. By the stimulation of warmth and food, we still managed to cling to our high hopes about the remainder of the distance to be covered, now reduced to approximately 1,960 miles.

This optimism was somewhat strained as we continued the following day. A check of our fuel indicated that the car's consumption of oil was about equal to that of gas. The sky was leaden and a steady drizzle continued to fall. In an attempt to revive our sagging morale I remarked to Grace that if the early pioneers could span these vast plains by ox-cart, we should be able to do so with the added amenities of a motor car and roads. She merely replied that the circumstances that formerly prevailed were probably the reason they got where they wanted to go. The evident truth of her remark caused us to lapse into the silence of our thoughts once again.

With daylight, another disquieting symptom had been noted in the operation of our car. After driving a short distance, a large thermometer mounted on the radiator rose to indicate a maximum temperature soon followed by the emission of steam from its environs. The cure was to stop and fill the radiator with water from the wayside puddles, a remedy that had to be frequently repeated.

Because the rain continued to fall, the use of our tent was impractical, so the journey had to be continued until we arrived in Calgary at two o'clock the following morning. We found our way to a place beside the Elbow River called Sunshine Auto Court. This was not the sort of

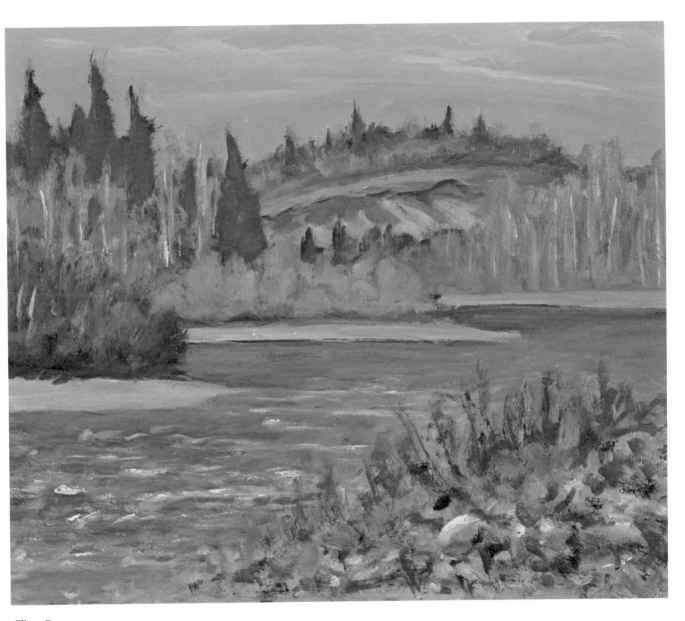

Elbow River, 1973
10½ × 13½″ oil on wood
Collection of Grace Turner

spot that might be regarded as a holiday resort. The name by which it was known left a lasting impression upon my mind; it was totally unsuit-able to the conditions that prevailed at the time. In the middle of the night in mud and puddles a few rustic shelters marked the guest accom-modation. If any surroundings existed that might have been calculated to deprive us of our last dregs of cheer and hopefulness, we had found them.

In an attempt to test my theories about meeting daily expenses and to recoup those already made, I took my portfolio of sketches to Calgary the morning after our arrival. After several calls in which I was not even invited to show my wares, my hopes were reduced to despair and I hurried back to the waiting family to get away as soon as possible from the inhospitable environment. On that occasion, if I had been told that some day I would choose Calgary as the site to establish an art gallery, I would not have believed it.

The following days marked some improvement. The sun came out and I sold my first sketch even though it took six hours to complete the deal. It was 2 P.M. when I called on the proprietor of the Golden Rule Department Store. After I had outlined my objective, he became interested in what he considered my enterprise. It reminded him of his own efforts to wrest success from a meagre beginning. He proceeded to tell me his life story in detail until 6 P.M. Because he was not finished, he invited me to return after supper so that he could continue the narra-tive, which he did until closing time at 10 P.M.

During this prolonged interview, I had not had an opportunity of returning to my original purpose of asking if he wanted to buy a painting, and only succeeded in doing so as we shook hands to part. It was a long hard day, but at least I had earned a much needed five dollars.

This heady success caused me to abandon the wisdom of taking the shortest route and instead to detour through a more southerly part of the province that I hankered to see. By doing so we found ourselves in an area very similar to the Arizona desert where cactus grew on the parched ground.

On the wide expanse of flat country that surrounded us, the little tent was set up, and while Grace read the story of "The Three Bears" to coax the children to sleep, I sat outside, assailed by my conscience.

What was I doing in the middle of a desert with two women, two small children, a broken-down car, a box full of indifferent pictures, and no money? For this I had given up the security of a monthly pay-cheque? While thus engaged in a torment of self-accusation and remorse my unhappy meditations were suddenly dispelled by Auntie Elsie.

She approached with the news that she had been studying something called an ephemeris, a table of charts dealing with the subject of astrology of which she was a student. She said that I could cheer up as the ephemeris indicated that everything would improve the day after tomorrow. She told me that I had Venus rising in my third house, which made me artistic.

Even though we had entered an area where the weather provided sunshine, our first week of heavy rains had left all our belongings fairly damp. But we could now use our tent and Grace prepared all our meals over an open fire, using an old grid from a cook stove supported on stones. For sleeping accommodation, we occupied the tent while Auntie Elsie slept in the car, which she valiantly declared was quite comfortable.

Our course led us from the desert surroundings to the dust bowl of southern Saskatchewan. Here the scene was indeed melancholy as the wind whipped the soil from cultivated areas so densely that at times it was necessary to drive with the lights on to avoid possible collision with traffic going in the opposite direction.

Through the veil of dust, the ghostly shapes of tumbleweed danced weirdly across the landscape, piled up against barbed wire fences, and helped to create deep drifts of soil that formed in the ditches along the roadside. At intervals the outline of deserted farm buildings could be seen, abandoned by their former occupants, defeated by nature and the depression. It was a scene redolent of misery and hardship and a most unpromising field for the purveyance of art.

At Regina we set up our little tent on the edge of an artificial lake, which provided an interesting contrast to the magnificent provincial Parliament Buildings that rose impressively on the opposite shore. The proximity of this site to the lake inspired the two women to undertake a session of clothes-washing and while they were thus engaged, I took my box of pictures to the city. It was now "the day after tomorrow," bringing the hopeful promise of the stars.

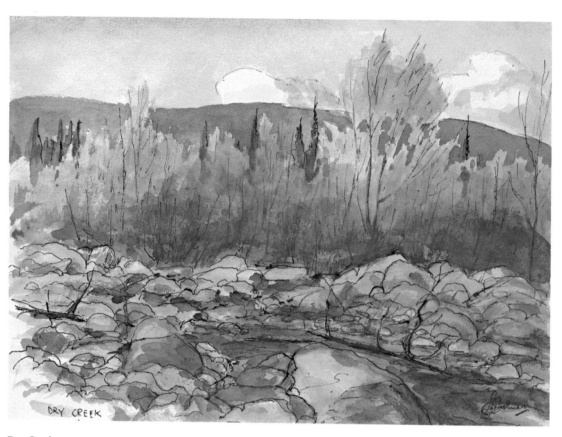

Dry Creek, 1975
10¼ × 14¼" watercolor
Collection of Grace Turner

I had never before visited Regina and therefore the city was entirely strange to me. Walking along its main street, wondering where to make my first contact, I found myself outside the offices of the Chamber of Commerce. Entering, I inquired if anyone was aware of local people who might be interested in art. The person I spoke to said he had little information on the subject but suggested that a lawyer named H.E. Sampson sometimes bought pictures and provided me with his address.

My first impression of Mr. Sampson was of an elderly man of somewhat austere appearance and I felt extremely nervous in broaching the object of my call to him. I asked him if he was interested in pictures, which seemed a foolish question when I had immediately noticed that his office was adorned with some good paintings.

His reply was that it all depended upon what kind of pictures. Although my self-confidence was rapidly shrinking, I explained my objectives and he invited me to show my work. Taking the sketches from the portfolio, he placed them around his office in any convenient space and proceeded to examine them without comment or expression that would provide a clue to his opinion of them. After some time, he picked up his telephone and said to someone at the other end of the line, "Come over to my office and look at some pictures." Soon we were joined by another man who also scrutinized the sketches in silence.

While this went on, my nervousness increased and I felt most uncomfortable as no immediate reaction was apparent in either of the two men. At last, Mr. Sampson said, "I like these—I will buy these two," and his friend chose two more.

Not only did this sudden bonanza mean so much materially, but the feeling of encouragement went far to restore my lost confidence. Following the transaction, Mr. Sampson told me he was the president of the Alpine Club of Canada and that my sketches, some of which I had made during a brief holiday in Jasper, appealed to him for that reason. He also advised me to contact the local head of the Alpine Club in Winnipeg, if I ever got there, which later proved of tremendous help.

My first impulse after leaving Mr. Sampson was to rush back with the good news to my wife, but I decided to try again while luck seemed to be with me. This time I chose the Public Library. I felt sure the people there would be aware of likely patrons.

Mr. J.C. Honeyman, the librarian, received me most kindly and showed keen interest in my project. He, too, bought a sketch and tried very hard to put me in touch with other people who might do so, but all of them were unavailable.

All this had taken several hours of time. Feeling that the sale of five sketches was a fair reward for the day, I went back to the auto court to report that we were now richer than we had been at the start of the journey.

In a jubilant frame of mind, although slightly marred by a severe toothache, I decided that we should press on toward Winnipeg. Pressing on suggests progressing at high speed, but this was not the case. Our engine was still heating up and the complaint had worsened to a point that it seized up at intervals, thus creating considerable delay. When such interruptions occurred, Auntie Elsie clung to the theory that in all times of difficulty or frustration the best antidote to consequent annoyance was a nice cup of tea. Immediately we were brought to a halt and she went about to gather sticks for a fire to boil the kettle and provide this great solace to our ruffled spirits. It may not be too much of an exaggeration to say that little heaps of tea leaves were left right across the Dominion to mark our triumph over adversity.

Apart from the malfunction of our engine, other small incidents impeded our headway, such as the loss of a tire from the trailer, which we did not detect until too late, although a long search was made over many miles we had already covered.

Due to these conditions, it is not surprising that the distance from Regina to Winnipeg took us three days to drive. We spent the night before our arrival in Winnipeg on the bank of the Assiniboine River, a site we afterward discovered was also within the boundaries of an Indian reservation. We were undisturbed, but by now we could easily have been taken for members of the darker-skinned race.

One of the great advantages we enjoyed was that we could readily find a place to set up camp unhampered by fences or No Trespassing signs and, as the weather had become very warm, conditions for camp life were extremely pleasant.

We had decided to stop short of reaching the city for the purpose of improving our appearance as much as possible. The river provided a means for another session of washing clothes. Grace had thoughtfully brought along an iron, which we heated on the camp-fire. Finding an old board and bracing it between the convenient forks of a tree, she soon provided me with a clean and ironed shirt and I took advantage of the facilities to press my only pair of trousers.

Even with these painstaking efforts at sartorial improvement, we must have presented an interesting sight for the citizens of Winnipeg as we entered their midst. Our car alone was sufficient to arrest attention for, apart from its strikingly derelict appearance, towing an odd-looking appendage, the course of our travels had added unusual characteristics. The first stage of heavy rain had so impregnated the car that mildew and various types of fungus now adorned the interior. Passage through the dust bowl of Saskatchewan had enabled a variety of wild flower and weed seeds to lodge in the tarred roof, and subsequent warmth and sunshine had now brought them to fruition. Galardias and harebells vied with buttercups and thistles for prominence in the profusion of our rooftop display.

If this gave rise to comments as we passed along the thoroughfares of Manitoba's capitol, public interest was probably diverted by our own appearance when we alighted. The two little girls were clad in sun-suits while Grace followed their example as closely as possible in shorts and a halter. Auntie Elsie, as fitting to one of more senior age, selected a less revealing but suitably sporting costume consisting of a loose blouse and jodhpurs. I added further variation to the scene by appearing in plus-fours. We soon concealed ourselves from the public gaze, indulging in the comparative luxury of a cabin after a week of tenting.

Acting on the advice of Mr. Sampson, my first call the next day was to the newspaper office, where I learned that a Mr. McCoubrey was the head of the local branch of the Alpine Club and employed as chief draftsman for the C.P.R.

Making Mr. McCoubrey's acquaintance was certainly one of the most fortunate highlights of our adventure. Recounting to him the experiences of our journey thus far and our ultimate goal caused him great amusement. I had not failed to point out the hazards under which we had embarked on our trip.

Having selected one or two of my sketches for himself, he then put on his hat, picked up my portfolio, and told me to follow him. We got into his car and drove from place to place around the city stopping to make calls at various homes and offices. Wherever we entered, having found the person he sought, he would display the sketches and simply ask, "Which one do you want?"

By this direct method of approach, each time the question was asked it met with a successful reply. All I had to do was stand by and gratefully receive the proceeds as they were handed to me. We were even entertained at a luncheon by one of our patrons.

On returning to Mr. McCoubrey's office I tried to express the extent of my gratitude for such wonderful help and, finally, to bid him goodbye. Upon this he said, "Oh, you can't leave yet. We have some more people to see tomorrow," and made an appointment for me to be at his office in the morning.

The same method brought similar results the next day. I had to explain to some of our customers the locality the sketches depicted, and sometimes I had to apologize that they not only represented that particular scene but also carried with them actual specimens of the flora and fauna of the place, which had adhered to the wet paint during the process of creation.

As a result of the kindness and help of Mr. McCoubrey we were now comparatively rich. We probably had as much as seventy-five dollars. In these affluent circumstances we decided to drive straight on to Toronto without making any further efforts to sell pictures.

At the time it was necessary to travel part of the distance through the United States. We crossed the border at Emerson, Manitoba. We made our last camp on the Canadian side the night before doing so.

The American customs officers eyed both our vehicle and ourselves with some suggestion of dubious wondering. I expect we looked like we might become a public charge, but after informing them of our intended destination, they let us through.

Travelling on paved highways, it was as though the old car had received a new lease on life, although it still heated and seized up on us. While it was running, however, it was much smoother and more comfortable than on the gravel and dust to which we had been accustomed.

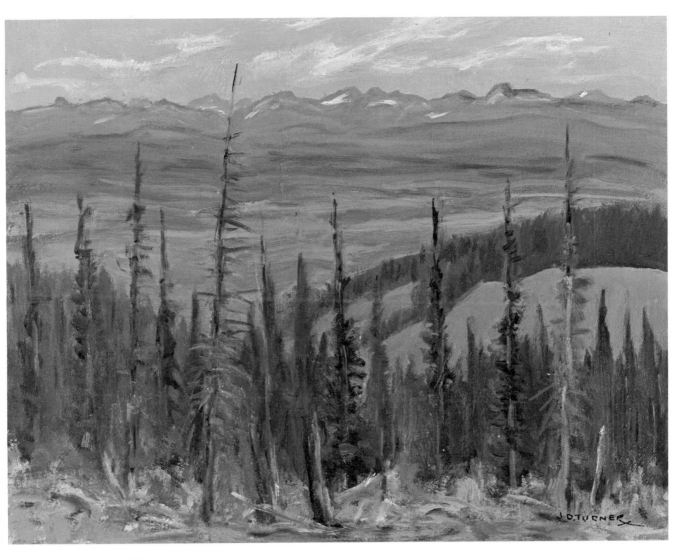

Skyline Trail, Porcupine Hills, 1966
10½ × 13½'' oil on canvas board
Private Collection

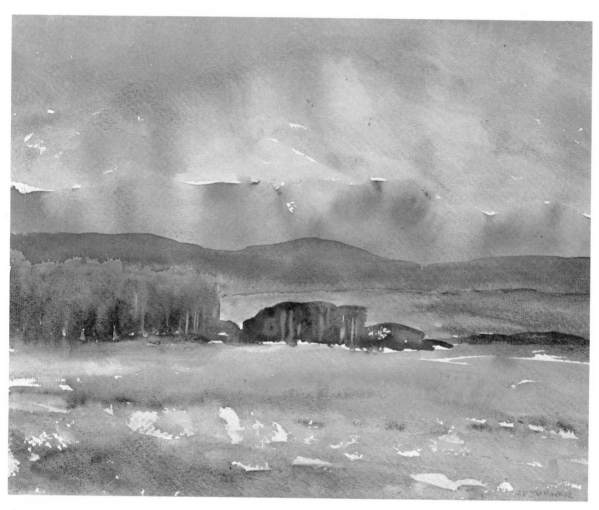

Sun and Rain, 1972
11½ × 11½'' watercolor
Collection of Grace Turner

Although we had frequently sought a cure for the car's heating problem by consulting supposed experts in garages, none had been able to effect a remedy. At Duluth, Minnesota, a service station operator said he could fix it easily. He said the radiator was plugged and he would blow it out with an air hose for one dollar. So we left him to it while we strayed to a nearby park for a picnic lunch.

When we returned in a short time we were dismayed to learn that the operation had not been a success. The pressure exerted by the air hose had blown the ancient radiator to bits and the man and his assistant were trying to reconstruct it with a soldering-iron.

We were told to come back about supper time and returned disconsolately to the park. The only ones pleased by the delay, if not disaster, were the kids, who had found a delightful stream to paddle in.

At about six o'clock we again approached the filling station in fear and dread both as to whether they had been able to fix it all and, if so, at what enormous cost? We found them just completing the job by refilling the radiator and with the cheerful news that it was as good as new. Even more gratifying, when asked for the bill, the reply was, "One dollar." He had worked hard with his helper for hours yet had honestly stuck to his original quotation!

Starting off again in a mood of elation at the successful outcome of this frightening experience, we had only gone about two blocks when the customary steam arose in front of us indicating that all the delay, effort, and anxiety had been in vain. Our spirits fell as the thermometer rose.

It was evening and the environs of Duluth were thickly populated. As we progressed and dusk changed into darkness and it became increasingly difficult to spot a likely place to pitch our tent for the night. This blind search continued until it became very late. In desperation we decided to take the first side-road and hope that a suitable corner would present itself. Soon we were off the highway following a narrow road leading up a hill; at the summit we could see a group of tall trees silhouetted against the night sky.

We were dog-tired. This at last looked an appropriate place to call a halt. After quickly putting up our tent, we were all soon fast asleep. In the morning we awakened to find ourselves surrounded by head stones, having "rested in peace" in the middle of the cemetery.

Instead of wisely continuing on good roads via Detroit and Windsor, the shortest route to our destination, our thirst for scenery lead us to choose a more roundabout way through Sault Ste. Marie and along the shores of Lake Nipigon through Bruce Mines and Sudbury.

As soon as we crossed the border into Canada at Sault Ste. Marie, we found ourselves on some of the worst road we had yet encountered. Gangs of workmen were engaged in the process of what they claimed to be improving the road, which made us wonder what it could have been like before. With the aid of dynamite and road machinery, they had created an almost impossible havoc of mud and rocks. In places they had to practically carry us through.

It was a severe test for the stamina of our ancient vehicle but we survived the passage with no more damage than a broken front spring. With relief we finally came to the end of the "improved" part of the road and found ourselves once more on the comparatively smooth surface of the section yet awaiting the workmen.

After a day of such navigational difficulties we were glad to find a campsite in what seemed an idyllic spot under the sheltering fronds of great pine trees. Here it was easy to suppose we were the only humans ever to have set foot, so remote did it seem from the inhabited world. The cosy atmosphere of our hiding place plus the cheerful camp-fire and a good supper combined to impart a feeling of relaxation and well-being. In this mood we retired for the night.

Our heavy slumbers induced by the fatigue of the day and the silence of the deep forest continued for some hours until we were suddenly awakened by a terrifying noise that grew in intensity to a deafening roar. In the pitch blackness we awaited our immediate doom as the sound reached its awful maximum. At what seemed like the inevitable moment of impact, it gradually began to lessen and finally receded into a distant rumble.

We later found the cause of this frightening disturbance. Instead of being far from the haunts of man as we had supposed, we had pitched our tent within a few feet of the railway track, concealed behind our sheltering pine tree. Our peaceful dreams had been interrupted by a passing freight train. The least menacing of our experiences, it had certainly been the most terrifying.

We had now reached within a reasonable distance of our goal and the remainder of the journey was marked by only minor inconveniences. At one point the road dipped to a bridge crossing a creek. As we ascended the opposite rise, having given full impetus to our speed in order to do so, our trailer hitch broke and the two-wheeled appendage rolled rapidly down again, hitting a buttress of the bridge. While fortunate that it did not disappear into the creek, the experience did not improve the trailer or its contents, which were sadly mixed up. Among broken crockery, the spare tire came to rest on Auntie Elsie's best hat.

The most difficult task, having backed down and made repairs to the hitch, was to get the car up the incline again from a dead start and was only accomplished by additional power supplied by the two women pushing.

It was raining heavily, which in combination with other factors, caused me some annoyance. Getting out of the car on our next occasion to stop, I slammed the door to emphasize my jaded feelings, which shattered the glass window. This was replaced from there on by a piece of soggy cardboard.

The rain continued and at last we entered Toronto, as we had left Edmonton, in a downpour. When we drove into the city along Yonge Street, a policeman stepped from the sidewalk and held up his hand as a signal for us to stop. Fearing we had committed some offence that might result in a costly fine, we waited anxiously for his approach with the bad news.

Having noticed our license plate, he said, "Did you come all the way from Alberta in *that?*" We assured him that we had indeed. "My God!" he exclaimed and continued on his beat.

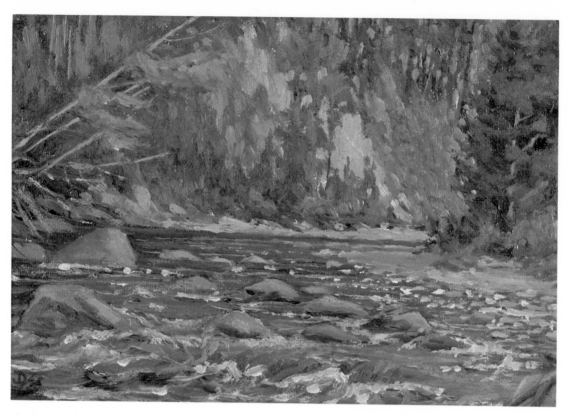

Credit River near the Forks, Belfountain, Ontario, 1935
4¾ × 7″ oil on canvas paper
Alberta Art Foundation

9 Home Again

Finding an auto camp somewhere along the lake front marked the journey's end. That we had made it at all was remarkable, as indicated by the policeman, and the comparatively short period of three weeks' travelling made it even more so.

A congenial campsite found the day after our arrival was situated in private grounds by the lakeside in Mimico and for a very nominal weekly fee. This was to be our headquarters for the remainder of our stay in Toronto.

In the meantime, immediate steps had to be taken to bolster our finances, which by now had again become almost entirely depleted. Somebody told me that the T. Eaton Company had an art gallery in their store on College Street and having just twelve sketches left, I went there and offered them the lot for the reduced sum of fifty dollars. They gave me a cheque and we were once more solvent for a little while.

My next call was on Jim Frise at the *Star* newspaper building, where he had his studio. I had long admired his humorous drawings.

Meeting him was a delightful experience as well as a most helpful one. I had brought with me several of my own humorous sketches and showed them to Jim, who said I could make full use of his studio and any materials he had.

He then introduced me to someone on the staff of Canadian Press who gave me a job to do some political caricatures, including some relating to the new Social Credit party in Alberta. The pay for these was minimal and, not wishing to impose on Jim Frise's great good nature, I carried out the work in the auto camp. Instead of drawing them, I cut out some of the caricatures in white paper, which were then pasted on black, giving a sharp contrast and somewhat unique effect. I did not see them in reproduction until they later appeared in the *Edmonton Bulletin*.

Job hunting produced no results. The familiar line-ups marked the scene of any vacancy advertised in the newspapers and the distant fields ceased to look greener once we had travelled to reach them.

I called on Arthur Lismer, then in charge of the Art Gallery of Toronto, and told him of our adventures and my purpose. He was always sympathetic and interested and blessed with a great sense of humor. Making his acquaintance for the first time was a great delight. He told me he had sent an exhibition all over Canada without making a single sale. At the time of our meeting he also introduced me to Fred Haines, then the head of the Ontario College of Art. They told me that J.W. Beatty was conducting a summer school at Kingston. The tuition was only $2.50 per week, but this was still beyond my reach unless I could earn money at the same time.

Sometimes to save the small fee for the camp at Mimico, we moved out into the country to the forks of the Credit River near Belfountain. Here in the bush I drew or cut out political cartoons and tried to make some more sketches of the kind I had sold on the way in Regina and Winnipeg.

One week-end we decided the opposite side of the river offered the most desirable campsite and forded the stream to reach it without mishap. When it came time to return, however, it had started to rain and to add to our discomfort, the trailer hitch broke again in midstream, which entailed feeling for something called a U-bolt among the stones under about two feet of cloudy water. It required time and patience.

86

When it was finally recovered and repairs made, our next difficulty was to ascend the opposite bank of the river, now wet and slimy from the heavy rain. Once more the ladies had to apply their muscles to the task of pushing and were generously coated with mud cast up by the spinning wheels of the car.

Our troubles were not yet at an end. Our car did not boast the advantage of a fuel gauge and the only way to ascertain the gas supply was to poke a stick into the tank. If it came out wet, everything was alright. In this case, the car having suddenly stopped, the test gave negative results.

I had to walk a long distance for a can of gasoline and was informed by the gas station operator that, in addition to the price, a deposit was required on the can. The total was in excess of my financial resources, which were reduced to about eighty-five cents. I got around the problem by leaving my raincoat as surety and walked back to the car unprotected from the falling rain.

Having finally reached our original campsite at Mimico, our fate now hung upon success in collecting for my latest cartoons. As the weeks passed in this hazardous manner, the time was becoming shorter to decide about the job in the coal office, on which I still held an option. Auntie Elsie had been equally unsuccessful in finding employment and I was increasingly aware of the risks being imposed on the rest of the party. Our future in Toronto seemed very precarious.

The only members of our group free of anxiety and completely enjoying a carefree existence were our two little girls, who spent their days paddling or playing on the beach blissfully ignorant of the difficulties that beset us.

Our decision to return to Edmonton was hastened by the news of the death of my father and we made immediate preparations to depart. We mentioned our intentions to one of our fellow occupants of the camp, who said, "You will never make it." He was a motor mechanic and therefore probably spoke with some authority on our chances. But, as we pointed out, we had no other alternative but to try.

This seemed to prey on his mind, for the next morning he started, without being asked, to work on our car to see what improvement he could effect in its serviceability. Sending me off to get one or two replacement parts from an auto wrecker, he applied himself diligently

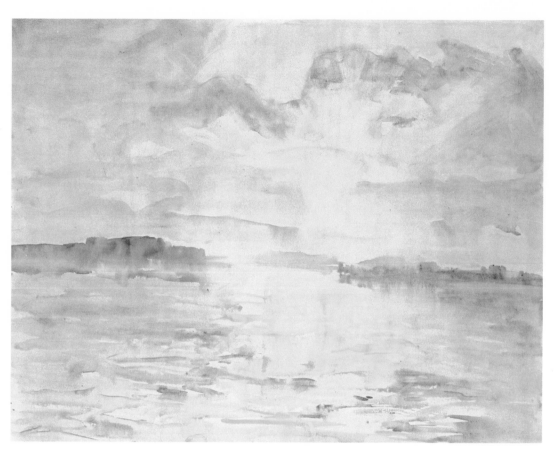

Jackfish Lake, 1950
19¼ × 25″ watercolor
Collection of Grace Turner

to the task, for which we owe him probably more than we shall ever know. As it was, his only reward was such peace of mind as he derived. I suspect it was precious little.

With the very few dollars remaining from payment for my last cartoon we set out, this time in the direction of London, Windsor, and Detroit. It was now August and the heat was intense. We stopped briefly in London, where I decided to try and peddle a couple of sketches. My first call was a dentist who bought them both, so we proceeded on our way with minimum delay and an additional ten dollars.

The heat was almost unbearable, augmented by that generated by the engine. As well as seriously affecting the operation of the ancient machine, the heat forced us to make frequent stops due to physical exhaustion.

By slow and painful progress, after about three days we reached a place called Gary, Indiana. It was about noon, but so great was the heat that we decided to remain until evening, sheltering under the trees in a public park.

It was our optimistic plan to drive on when it became cooler and to find a suitable campsite before reaching Chicago. When it came time to move on, the road we followed out of Gary was lined with large factories and industrial buildings, but instead of diminishing, they increased in density as the highway also widened to accommodate a greater congestion of traffic.

The atmosphere was stifling even though the blistering sun had set. As darkness increased, headlights were turned on making a further contribution to the hazard of driving in the stream of speeding cars. The prospect of camping in such an environment was remote indeed.

Soon policemen appeared on point duty to keep the traffic moving and instead of affording us a means of rescue, impatiently waved us onward. We had failed to realize that Gary, Indiana, is a mere suburb of Chicago, Illinois, even if their geographical description would make it appear otherwise. Thus we were engulfed in the Chicago traffic with no means of escape, our panic increased by the boiling radiator and the assumption that we must be running short of gas.

Somehow we managed to work our way into the curb lane and replenish our supply of fuel and water at a gas station before plunging once more into the rushing tide of traffic in what appeared to be a main

artery along the lakeshore. It was getting late and the children announced that they were hungry, which applied to all of us since we had eaten no supper. Grace, however, was prepared for this emergency and produced a loaf of bread and some butter from her hand luggage and proceeded to cut slices and hand them around as we made our difficult passage through the heart of one of the world's largest cities.

It took many hours before there appeared any sign of thinning traffic and population but eventually we seemed to be on the outskirts of the city. Once more we were determined to escape from the highway and to follow any side-road at the first opportunity. The combination of heat, nervous tension, and natural fatigue had reduced us to complete indifference about anything other than coming to a halt. Taking advantage of the first turn-off on the highway, we pulled on to a grass verge after travelling a short distance and disregarding the likelihood of being in somebody's backyard, we stopped and put up our tent. It was now after midnight and pitch-dark.

By a stroke of extraordinary good luck, as though to compensate us for the ordeal of the previous night, we awakened to find that we had blindly settled upon an ideal camping place only a few yards from the banks of the Des Moines River, which flowed peacefully beside us. We took full advantage of our proximity to the river to have a good wash followed by a hearty breakfast prepared by Grace over an open fire. These circumstances did much to restore our morale, which had only a few hours before reached its lowest ebb when we were locked in Chicago traffic.

We needed all the restorative influences that could be provided, for, although our immediate surroundings were pleasant, we were broke. Grace, with commendable foresight, had made preparation for this situation by holding on to a stock certificate worth fifty dollars in shares of the firm she had been employed by before marriage. She had earmarked the certificate for use only as a last reserve in emergency, a condition which now confronted us.

Before leaving Toronto she had put the shares for sale with a broker with instructions for him to mail the cheque covering their sale in care of an uncle living in Chicago. We broke camp and went in search of the uncle whom we had never met before, first filling our gas tank and thus depleting our remaining capital, now reduced to less than one dollar.

Not knowing the city, we had a considerable time locating the residence of my wife's uncle, but when we at last arrived unexpectedly at his door, we were welcomed with tremendous hospitality. Even though our appearance must have indicated our dire condition, we pretended to be on a carefree holiday and our embarrassment was lessened by his charitable sharing of the pretence.

But no cheque had come and for a couple of days we waited in terrible anxiety. At last we were once more saved by the bell, in this case the doorbell, signalling the arrival of our guardian angel now disguised as a postman bearing the means of our rescue.

Less the broker's commission, the cheque totalled under fifty dollars. It was all we had to cover the remaining expense of our journey to Edmonton. If nothing went wrong, it would be difficult, but if anything serious arose, we would be sunk.

Although extremely vulnerable, we were anxious to be on our way and accept the challenge whatever its outcome. We bade our kind hosts farewell and for a time all went well.

We had occasion to stop in one place to refuel, which was a mere wayside gas pump outside a country store in a remote part of the country. The old man who shuffled out to attend us, listening to the convulsions of our car and noting its steaming radiator said, "Timing's wrong," whereon he lifted the side of the hood, removed the distributor cap, gave something a push, and closed the hood again. From then on our motor ceased to heat up. He had performed, without cost, a simple operation that had baffled the experts across half the length of two nations.

With this great advantage we moved steadily onward covering the distance to Winnipeg without any considerable delay. Gasoline was cheap during the depression so that our actual travelling costs were small. Food was only a fraction of present-day costs, our fare was simple, and we prepared our meals over the camp-fire.

I had written to Jim Mann at the coal office telling him of our intention to return and asking him to write to me at General Delivery, Winnipeg, to confirm the job was still available as agreed upon previously. I had some doubt whether the business had continued to survive.

At Winnipeg I found his reply waiting for me. It stated that I must be back by a specified date as he was going away himself and would

91

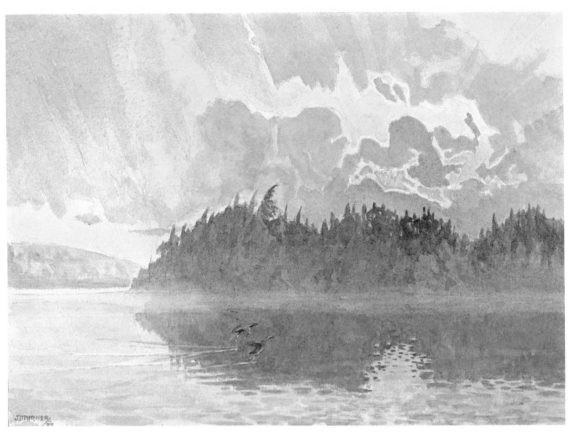

Astotin Lake, Elk Island Park, 1937
7½ × 10½'' watercolor
Collection of Grace Turner

otherwise have to get someone else to take over if I was not there. The date he named was so immediate that in order to be on hand at the stated time we would have to travel non-stop.

Without wasting a moment we pushed on, only breaking long enough when necessary for fuel or for a meal. Leaving Winnipeg late in the day, we drove on all night and the next day, which brought us to the middle of Saskatchewan by late afternoon. Here we had our first delay in the form of a flat tire. Having by now acquired a lifting jack, it was soon replaced with the spare, and we moved on with as much speed as possible to offset the lost time. Another tire went flat a short time later.

Nothing could be done with two flat tires. There was no other traffic on the road, so I couldn't hitch a ride to the next village. I left the women and children stranded in the wide flat prairie and began rolling one of the tires down the road hoping for a lift, but none came. A chilly wind was blowing and it took more than an hour of this tedious and tiring work before I finally got to the next service station where the tire was repaired.

The return seemed more promising; I caught a ride going in my direction. Unfortunately this terminated only halfway back when the driver turned off to follow a different direction. Again I had to roll the tire for the remaining distance. When I arrived the rest of the party, having spent several hours in the cold, had almost given up hope of my reappearance. Because of this serious setback, we put the old car to its fullest test of speed. It was imperative that I reach Edmonton to make sure I got the job and time was running out. We had just one more full day to make it.

We reached a point somewhere near North Battleford, Saskatchewan, when alarming noises issued from our engine as though it was totally disintegrating. Speed dropped to about fifteen miles per hour but despite the sounds, it kept going and we dared not stop to investigate lest it should never start again.

Inquiries at the next service station revealed that we had a broken piston valve, putting one cylinder out of operation. We also found that both the cost of repair and the time required to do it were prohibitive so that the only alternative was to continue the rest of the journey on three cylinders.

Creeping on at an incredibly slow speed we continued throughout the night, which was made worse by a violent storm and heavy rain. At

about 5 A.M. we were forced to halt when the children awoke hungry. The rest of us were nearly exhausted with fatigue. Stopping right in the middle of a wet muddy road we gathered some sticks and with difficulty built a fire on which Grace cooked porridge while the rain continued to fall, making her efforts more difficult.

Once we had filled ourselves with the warm and comforting substance, we recovered sufficiently to continue. Now at last in Alberta, we were not far from the border town of Lloydminster and had a reasonable hope of reaching Edmonton sometime before the morrow.

To get the car started we now had to use the crank, as the starter had also given up the ghost. The evening found us in the vicinity of Elk Island Park. In the continuing rain we were halted by the misfortune of another traveller whose car had slid off the road into the ditch and to whom we offered assistance. In the general confusion of this incident, I somehow put my starting crank on the running-board and forgot to pick it up, so that it was irretrievably lost. This was not noticed for a while and we made a further short progress until the car stopped and we discovered that we had no means of starting the car again. We probably could not have restarted the car in any case because a sediment bowl had become loose, the gasoline had leaked, and we were out of fuel.

It was intensely dark and the storm continued. We were only forty miles from our objective and completely immobile. The road had no shoulder, so we had to leave the car where it was. Tired, frustrated, hungry, and disgusted, we went to sleep in the car disregarding the possibility of collision and accepting that chance as no worse than our present condition.

Very early in the morning a Mr. Pasternac of Mundare came along with his truckload of hogs heading for market in Edmonton. He hitched us on with a chain and dragged us to Jim Letcher's filling station in Forest Lawn, a suburb of Edmonton. Jim tightened our loose sediment bowl, filled up the gas tank, and gave us another crank.

With the help of the two women pushing we made it up Dawson Hill into Edmonton and to Frank's home. I borrowed some of my brother's clothes and reported for work at the coal office at 9 A.M. The job was mine and remained so for the next several years, undisturbed by artistic ambitions.

10 The War Years

Emancipation from the coal business came at last when on a bright fall morning in 1939 I made my way to the recruiting office of the R.C.A.F. As I did so, such was my patriotic fervor, that, like James Thurber's Walter Mitty, I began to weave dreams of martial prowess and, however inappropriate to aerial combat, to see myself in some epic pose standing on a promontory of rock amid the smoke of battle, swathed in blood-stained bandages, clutching a sword in one hand and a flag in the other.

These visions no doubt encouraged me to assume a military stride and an expression suited to my stern and lofty purpose. Entering the recruiting office in this frame of mind, I had half-expected to be greeted with three cheers or some form of commendation for my sacrificial action. In this I was disappointed, for the atmosphere of the premises was completely devoid of emotion.

I was merely told to sit down on one of a row of very hard chairs where I remained for a considerable time apparently unnoticed, much less acclaimed.

Finally, a corporal standing behind the counter signalled to me to approach by a jerk of his head. Producing a large form, he said, "Name in full?" and proceeded with other questions of routine nature: age, occupation, marital status, and so on.

"Religion?" he next commanded. I replied that although I had been brought up in the Church of England, I felt a strong disagreement with some of the recent decisions of the Lambeth Conference, particularly with respect to changes in the Book of Common Prayer. The corporal eyed me coldly and terminated further discussion by asking whether I suffered from varicose veins.

When all the blank spaces on the form had been filled, I was told to go and sit down again. Other prospective warriors occupied similar chairs and we eyed each other disparagingly; we all looked callow, un-romantic, and unmilitary. It was not the stirring spectacle suggested by such newspaper headlines as "Canada's Young Manhood Flocks to the Country's Aid."

After another considerable lapse of time I was directed to the recruiting officer for a personal interview. His questions dealt less with the concrete details of my biography and concerned matters that might enable him to assess the general character of applicants.

Having satisfied himself that my intellectual endowments were sufficiently below average, he rang a bell and instructed the sergeant to provide me with forms for application for commissioned rank. These I was told to return on completion together with certificates of birth and education and testimonies of good character from reliable sources.

Seeking the co-operation of various leading citizens and churchmen who had probably no recollection of having seen me before, I was none the less supplied with the required testimonies, presumably because they all believed that it was their patriotic duty. Mr. Hilton, who had been the principal of the Technical School I had briefly attended in 1917, was still in Edmonton, and evidently to satisfy his sense of humor, provided a tribute to my scholastic achievements that bordered on the burlesque.

When all the documents were returned, I received a telephone call to report immediately for a medical examination. Being in good health, I felt little concern of being unsuccessful and once again allowed my imagination to create impressive visions of military glory.

I found the medical board as lacking in emotional quality as the recruiting office. I was told to divest myself of all clothing in what seemed like a large public gathering. To increase my embarrassment, I was next instructed to stand on one leg with my eyes shut, which seemed a ridiculous pose, for the purpose of testing my sense of equilibrium.

Following this, I was then asked to move a large leaden weight up a glass tube by blowing through a rubber hose. After nearly exploding my lungs, I succeeded in creating a slight oscillation in the weight, which seemed to me a considerable feat, although my examiner was unimpressed and told me to blow harder. There followed a number of similar exercises designed to strain one's physical stamina and I was led to wonder what might have been the altered course of history if Marlborough, Nelson, or Wellington had failed to measure up to these demands.

Having completed all requirements for enlistment, I returned to the coal office, where my excitement at the prospect of a new adventure gradually died as months passed with no response from the Air Force. The dull winter routine followed in the same pattern as previous years and not until the spring of 1940 was I notified of my acceptance. A mimeographed form letter arrived by post, which, when the blank spaces had been filled in, stated that I had been appointed as an equipment officer and to report on a specified date to a training centre at St. Thomas, Ontario.

On arriving at St. Thomas, I found that I had been consigned to a large mental hospital that had been taken over by the R.C.A.F., who had recognized it as ideal for the purpose of initiating newly recruited members into the mysteries of equipment procedure. Instruction was based upon textbooks written during peace-time and based more upon theory than practice.

With the advent of the Joint Air Training Plan, in which a number of Allied countries participated and shared costs to produce aircrews, the situation was drastically altered so that the regulations contained in the textbooks were subject to continual amendment. These were type-

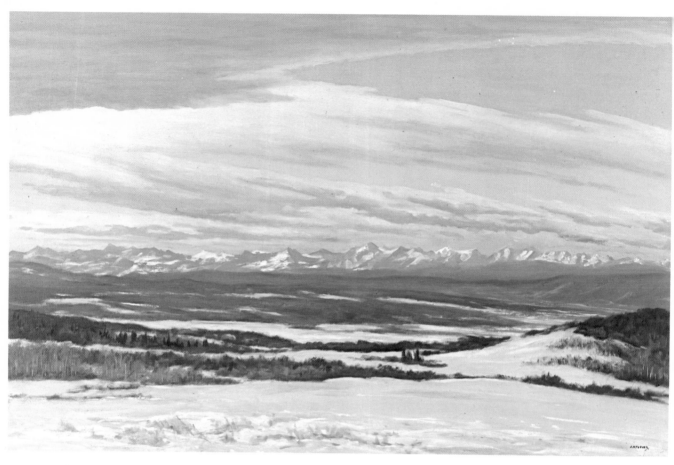

Winter Landscape, 1974
32 × 48″ oil on canvas board
Private Collection

written on sheets of tissue paper with numerous faint carbon copies and cut and pasted on the relevant page of the textbooks until the latter gave the appearance of frothing at the mouth.

These rapid alterations resulted in instructors as confused as their students. Examinations held at the completion of the course were therefore more in the nature of a formality than a test of knowledge. Everybody was given a 70 percent average and shipped off to equipment depots or units to shift for themselves with the aid of the continuing stream of amendments that followed them.

My first posting from the training course was to No. 7 Equipment Depot, Winnipeg, to which I travelled in the company of my fellow trainee, Duff Roblin, who in later years became Premier of Manitoba. A few weeks later I was sent to No. 11 Equipment Depot, Calgary, which was still in the process of construction.

There being no accommodation ready for occupancy by the officers, we were given a living out allowance and told to find a place to live in the meantime. I found a small furnished bachelor suite in the middle of town conveniently equipped with a small kitchen and all necessary domestic utensils. In these circumstances I first met H.G. Glyde. One evening my neighbor knocked on my door and asked me to lend him some extra dishes. He was entertaining some friends for dinner.

His call interrupted me in the process of trying to paint and noticing how I had been occupied, he said one of his guests was an artist and invited me to the party. This was an occasion to celebrate the birth that day of Glyde's youngest son. The dinner party was a gay event, resulting in friendships that have since endured to the great enrichment of all our lives.

Art was not entirely absent from activities in the Air Force. Flight Lieutenant Charles Goldhammer, a professional artist, was officially engaged to promote interest in art among the men as a diversion from less worthy leisure pursuits. In 1944 an exhibition of R.C.A.F. art was organized and shown in the National Gallery in Ottawa. It included works by a good many professional painters who were in the service, covering all ranks from Air Vice-Marshall to Aircraftman. In the impressive illustrated catalogue of the exhibition, I was privileged to be represented by a small sketch of a log jam.

My work at the equipment depot was to outfit and maintain the

supply of all necessities for various training schools established under the Joint Air Training Plan. The list of such requirements covered everything from clothing and barrack and mess room furnishings to aircraft and automotive spare parts, from spoons and tea to propellers. While my function was equally important as that of the men actually in combat, it did not bear any resemblance to the epic scenes of my dreams at the time of my enlistment. Other than for mere superficial differences such as wearing a uniform and dealing in a variety of products other than coal, my new occupation was not such a great change. I was behind a desk and as remote from danger or conflict as ever.

In order to bring my dreams closer to reality, I asked for an overseas posting and was sent to Newfoundland, a doubtful improvement except that it was an operational station as contrasted to those for training purposes. Bomber squadrons operated on convoy duty and sub-hunting, and a fighter squadron also existed. The station was a target for saboteurs who took full advantage of the very lax security that existed and exercised a free hand in tampering with aircraft and setting fires. My equipment section was totally destroyed by this means.

After spending a couple of years in Newfoundland and then Moncton, New Brunswick, I was posted back to Calgary, to No. 4 C.&M. Unit at Currie Field, and able to live at home with my family. At the end of the war, prior to final discharge from the service, we were given a month's "Retirement Leave." To make up for the often long periods of separation, Grace and I decided to celebrate our permanent reunion by going on a family holiday. It was agreed that a motor trip through the mountains would be the ideal arrangement if we could acquire a car, then a rare item and expensive.

Scrutinizing the Want Ad columns of the newspaper, we came upon an advertisement for a 1927 Chevrolet Sedan and were immediately seized with nostalgic memories of 1935 when we had travelled to Toronto and back in a car of the same model and vintage on our epic journey in search of artistic progress.

The address given in the advertisement led us to a barber-shop. In the yard behind, we beheld the twin of our former vehicle. It had all the familiar signs of abuse and decay. Guided by our emotions rather than our common sense, we paid the required price of two hundred dollars

and drove home, recognizing all the symptoms so well remembered: the creaking wooden spokes of the wheels, the acrid fumes drifting up through floor boards, and so on.

A friend and fellow Air Force officer said he had a splendid two-wheeled trailer he would lend me; we were thus able to duplicate exactly our former entourage of years gone by. After a short trial run, we loaded up with everything we might need and a lot that we didn't need and prepared for departure.

Apart from our children, who had grown considerably during the six years of war, we had a large greyhound dog, Niki. This put a considerable tax on the capacity of our car. We had to practically fold the dog in the middle to get him in. He would occupy the entire back seat, relegating the children to the floor.

It was a sweltering hot day in August when we finally commenced the trip and the oppressive heat presaged a violent storm. But all went well for the first thirty miles and morale remained high. Realizing that emotion swayed us to buy the car, our two daughters continually sang a then popular ditty, "I'm Goin' to Take a Sentimental Journey." At first it amused us but later, when confronted by mechanical and other problems, it became a considerable irritant to my already troubled conscience.

By late afternoon evidence of the approaching storm was apparent even though the sun still shone and the heat was relentless. At this point one of the children glanced out of the back window and announced that the trailer was on fire.

A coil of smoke rose from under the wooden box. Its varied contents were quickly unloaded into the roadside ditch and the vehicle turned on its side. A hasty examination revealed that instead of the wheels turning on the axle, the entire axle revolved due to lack of lubrication. The weight bearing down on it created friction and consequent charring of the woodwork.

This occurred on a stretch of road that had been freshly oiled on which I knelt to the detriment of the new grey flannel slacks I was wearing. We set up the tent in an adjoining field and hauled our scattered belongings into it, a task just completed as the storm broke with great violence of thunder, lightning, and rain.

Huddling together among the confusion of our rapidly moved effects within the confines of our very small tent, Grace mysteriously provided the stimulant of food and drink. Thus sustained I took the empty trailer to the village of Cochrane some four or five miles away. The local garage man was unwillingly dragged from the comfort of his home until a late hour to remove the wheels, which seemed almost solidly welded to the axle, and apply the long neglected lubricant to restore their proper function.

In the meantime, Grace had restored some sort of order from chaos within the tent and we spent the night, by contrast to the day, in comparative comfort. The storm abated, the air cooled, and we slept.

The morning sun shone brightly. Fed, rested, and generally refreshed, we loaded the repaired trailer in orderly fashion and, with renewed optimism, proceeded on our way. We drove another thirty miles before disaster struck again.

The engine stopped at a point approximately half-way to our first destination, the town of Banff. My limited knowledge of mechanics was insufficient to determine the cause until, after considerable delay, a passing motorist of greater wisdom stopped and discovered a broken fuse, an item costing about ten cents. The motorist was, of course, travelling in the wrong direction. After walking some distance in the increasing heat, I was fortunate to be at last given a ride all the way to Banff, where I immediately purchased the required fuse.

Not anticipating these delays, we had previously arranged to be guests of the Glydes for dinner that evening. Geo Glyde was then engaged at the summer session of the Banff School of Fine Arts. Since we would obviously be unable to make it, I hired a bicycle in Banff and rode it some distance to their cottage to report our dilemma and make apologies for our absence. By that hour, the dinner had been prepared and was ready to serve. Without hesitation the entire meal was packed up and we drove to the point forty miles distant where the family awaited my return. We had a delightful picnic, installed the fuse, and drove back to the Glydes' house to enjoy their continued hospitality.

We must have had considerable resilience for, despite the delays in our journey already experienced, we continued, next arriving at Windermere. The member of our party who least enjoyed the experience was Niki the greyhound, who at every opportunity escaped and

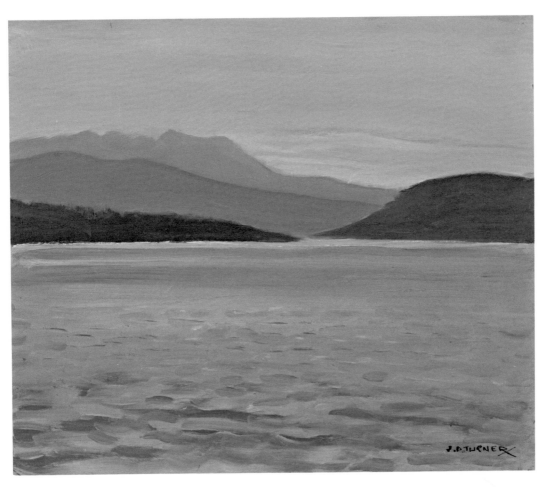

Sunset, B.C., 1975
10 × 12″ oil on wood
Collection of Grace Turner

Jasper Lake, 1939
10½ × 14″ watercolor
Alberta Art Foundation

hid in the surrounding forest, giving rise to long periods of search for him and his reluctant capture.

Having spent a few days' respite from our travels in the pleasant surroundings of Windermere, we felt undaunted in tackling the next route, toward Jasper National Park.

Nearing the Banff-Jasper junction, further difficulties arose in the operation of the car. We proceeded at a very slow speed in a series of jerks propelled apparently by the force of violent explosions. In this crippled state we slowly returned the thirty or forty miles to Banff for a further diagnosis and treatment of our ailing conveyance. Again we found haven with the good-natured Glydes until the process of repair had been completed.

There seemed then nothing to impede our satisfactory continuance. The car worked with what seemed like comparative perfection and we breezed happily along. Reaching a point called Saskatchewan River Crossing, we did not pause; we were not aware that we had left behind the last source of gasoline before Jasper, which lay in the remote distance of about one hundred miles or more.

Driving on with carefree enjoyment of the improved operation of the car, we came to what is known as the Seven Mile Hill, a steep upward gradient of that distance. This was too great a challenge to the car, which soon gave evidence of being less robust than we had thought. Only a few yards would be gained before the engine stalled under the weight of its efforts, and to overcome the natural tendency for it to roll backwards, we placed a large stone under a rear wheel at each interval between the distance gained and the point at which the car stalled.

It was a long and wearisome ascent, marked all the way by the series of stones that remained to mark our eventual triumph. But at the top we could not coax the car from a stalled state. I spent considerable time examining the engine, removing bits, blowing through them, and so on, but without results. While thus engaged, Grace made sandwiches. Handing one to me, a whisky jack flew down and relieved her of it before I could wipe my hands to reach for it myself.

After a long and tedious investigation of the engine, a bus at last came by and the operator stopped to offer assistance. "Got any gas?" he asked. This was the one cause that had escaped my mind. The only way to find out was to poke a stick into the gas tank. The stick was dry. Due

to wartime restraints, tourism and traffic were still minimal, but getting a ride on the bus enabled me to return to Saskatchewan River Crossing, a distance of forty miles.

It was necessary to wait a long time before transportation back to my again stranded family could be obtained. Finally, a young park official in a truck came along and solved the problem. Once the fuel was supplied, the car resumed its normal operation and the park official kindly agreed to drive ahead of us and keep watch that we did not meet with further disaster. The two girls found his companionship agreeable and rode with him.

It was fortunate that the remaining distance was practically all downhill as the quantity of gas in our tank was doubtfully sufficient to last. In order to conserve it I turned off the engine and coasted whenever possible and as there were many sharp turns and steep grades, the ride was a somewhat thrilling experience.

Approaching the town, we resolved that as compensation for the day's tribulations we should indulge ourselves with the finest meal that could be provided. But by then it was late evening and, to our disgust, all eating establishments were closed. It came to mind that it was also "Meatless Tuesday." All we could find were sandwiches, evidently several days old, at the railway station.

I next sowed the seed of future difficulties by attempting to avoid them. I had the oil changed. When this operation had been performed, we drove on, fully fuelled and confident that the lessons of experience had been learned. The mountain scenery of Jasper Park, the weather, and all things combined to spark a new enjoyment of what had been so far marred by moments of despondency.

We reached the sandy shores of Jasper Lake, about thirty miles east of Jasper, before the car broke down again. This occurred with symptoms of acute disorder, suddenly, and ominous sounds from the braking mechanism. This time we had run out of oil because the man who had changed it forgot to replace the plug.

Now grown accustomed to such circumstances, the children spent a happy afternoon playing in the lake and the soft sands surrounding it while Grace and I awaited rescue in response to our silent prayers. At last we found a mounted policeman, who was requested to report our difficulties to the garage in Jasper and to dispatch a tow truck.

Returning to town, many hours of work were required to make repairs. The only bright aspect of the matter was that the garage man had acknowledged his error and costs were limited to payment for parts. Nevertheless, I was in a very disagreeable frame of mind. Consequently, I determined to drive straight through to Edmonton, even though it was now late into the night. Fatigue eventually brought us to a halt near Edson, where we camped until morning.

The next day we reached Edmonton without greater incident than a couple of flat tires. We were also waved down by a policeman who pointed out that it was against the law to have no supplementary chain to our trailer hitch, a fault we promised to correct if spared prosecution.

Due to the variety of unforseen problems that had marked our journey, we wisely decided that the length of our absence on holiday should be reduced. After a short and welcome respite in the home of my wife's parents, we added our niece to our already crowded passenger list and headed for home.

Since we had anticipated a longer vacation at the outset, Grace had invited her sister and husband and family to utilize our house in our absence while they were on holiday in Calgary. We arrived very late at night and found them all in our beds and sound asleep. Once more, the tent was erected and camp established in our own backyard.

Winston Elliott, *Canadian Art Galleries,* 1947
16 × 12″ oil on masonite
Collection of Grace Turner

11 The Art Gallery

For nearly six years, the R.C.A.F. had provided me with an alternative occupation, and at the end of that period Grace and I had already decided upon the course we should follow. There was some optimistic belief that a new and better world was about to arise from the ashes of the old. Our contribution to this Utopia would take the form of the establishment of a fine art gallery. Calgary was the site chosen since the family was now established there.

Once released from the service, we lost no time in attempting to implement our plan in spite of the many obstacles, chief of which was a complete lack of capital. Calgary was not then the most fertile spot to choose for such a venture and apart from a couple of little "Art Shoppes," nothing of the kind that we envisaged had existed before in a place to which the label "Cowtown" had long been attached.

Once, on a week-end leave, my friend H.G. Glyde introduced me to A.Y. Jackson, and they invited me to go on a sketching trip to Canmore. While we were there, we were having supper in a local coffee shop and

in the course of conversation, Jackson asked me what I was going to do after the war. I told him that I was going to start an art gallery in Calgary, which seemed to amuse him. He intimated that I would stand little chance of success unless I had no very strong moral scruples. In his opinion, art dealers were generally not much different than the proverbial horse trader in the matter of ethics.

However, it was not a sudden idea on my part but one I had conceived long ago, even prior to the war, when the prospect could not have been more remote. I was then working for the coal-mine at a very small salary and slowly trying to recover from the effects of the depression. The outbreak of war in 1939 had provided an excuse to escape from the dingy coal office to which I was determined never to return. Whatever the obstacles, when the war was over, Grace and I would start our art gallery.

Premises, suitable or otherwise, were hard to find, particularly at the rent we were able to afford. Whatever dreams we had of a wide-stepped facade and a pillared portico leading to a series of spacious galleries were soon dispelled. After a diligent search, reality became a narrow staircase ascending to the second floor of a two-storey building recently converted from a warehouse for use as offices and stores. The second floor was occupied by a law firm in which one corner office about nine feet by twelve feet was vacant pending the arrival of an additional partner or similar requirement. In the meantime we could rent for fifty dollars a month. I went out and bought a second-hand desk and chair and we moved in.

The next essential was to stock the gallery with paintings, and my friendship with H.G. Glyde and A.Y. Jackson proved a useful source from which to obtain the nucleus of a collection. Walter J. Phillips, whom I also came to know through Glyde's introduction, was a willing contributor.

It had always been our purpose to maintain a high standard of art. These three men, who readily responded to our request for paintings, made it possible to establish this principle from the start. My past meeting with Arthur Lismer during our disastrous trip to Toronto also enabled me to add his name to our list of artists. Having gained the support of such recognized artists made it more easily possible to secure the co-operation of others to whom I was still a stranger. In this way, it

was not long before we had a small exhibition of paintings on the walls of our small gallery, but however limited in number and humble their setting, they none the less represented a very select group of Canadian painters.

Our next requirement was to publicize our existence. To offset the limited and inconspicuous nature of our premises, I arranged for a sign, inexpensive but large enough to suggest we were the sole occupants, to hang on the front of the building below our window:

CANADIAN ART GALLERIES

FINE ART DEALERS

Artists' Agents Frame Makers

The plural, "Galleries," was an amusing exaggeration, and the last item advertised was extremely daring because I had never made a picture frame. Nor did we possess the means of doing so, even if we were capable. In any case, picture frame moldings were almost unavailable as the war had diverted manufacturing to other requirements.

Fortunately, we had ample time in which to consider a solution to our problems. We were not embarrassed by an overwhelming rush of customers. The concept of an art gallery was fairly new to most Calgarians. Art appreciation was not very widespread and to many the idea of buying an original painting had never previously arisen.

From the beginning our greatest handicap was the lack of capital, which made it imperative that we create some immediate revenue. We could not sell pictures without frames or, if we had done so, we would lose the profit that would derive from that source. With this in mind, I purchased a cheap simple mitre machine, which was a combination of vice and saw. The only source of picture frame moldings was the local lumber yard. In a very limited range of sizes and patterns, the moldings were in their raw state and also of extremely poor quality.

We turned the basement of our house into a workshop and started experimenting with these rudimentary materials. In spite of the mitre machine, at first our cuts always seemed to vary several degrees from

the required angle. Cutting glass presented an equally difficult art, and we were soon deeply surrounded in sawdust and broken glass.

For transportation I depended upon a bicycle, which was purchased from Eaton's on the deferred payment plan. I carried picture frame molding from the lumber yard in lengths of ten or twelve feet or more balanced on my shoulder. I only had one hand to steer the bike, which was very difficult in traffic. I also transported finished frames from the workshop to the gallery, a distance of several miles.

Sales promotion called for serious efforts and we devised a variety of schemes. Having been so readily encouraged by several artists, we felt a strong obligation to show some results. We could not, of course, buy the paintings but took them on consignment at a commission of twenty-five percent on sales. At first we even paid for insurance while the paintings were in our hands, but this soon became entirely too expensive. We also had to increase the commission rate to one-third as time went on.

One idea for sales promotion was to have exhibitions sponsored by different charitable organizations, allowing them ten percent of any sales for whatever cause they espoused. Such exhibitions were usually hung in department stores or wherever the organization concerned was holding its tea or other function. The Independent Order of the Daughters of the Empire was one such group, and also the Quota Club, a women's organization for the relief and benefit of indigent elderly ladies.

Another scheme was to sell a painting to a business firm, which in turn would donate it to the public schools. A suitable plaque was attached to the frame to acknowledge the generosity of the sponsor. In this way, quite a good collection for circulation among the various schools was compiled.

When we had exhausted our attempts to sell paintings locally I took small exhibitions to Edmonton and Winnipeg, but not always with any profit after paying expenses. But it served to let our artists know we were making an effort.

Having no means of establishing a line of credit for the purchase of stock, I visited the local office of Dun & Bradstreet and explained my problem, outlining the details of our financial weakness and asking them to make as favorable report as possible in response to any inquiries. I don't know whether this ever had any bearing, but we were never rejected in establishing normal credit with any wholesaler. Fortunately, a

good friend in an established business willingly backed my thirty-day promissory notes at the bank when necessary.

Our finances were assisted for a time by a grant designed to help ex-servicemen in the process of civil re-establishment. I was given the sum of one hundred dollars per month for a limited period, which was of great use when so badly needed.

Of major importance was that Grace felt as dedicated to the cause as I did and worked just as hard in its accomplishment. Her capacity for management and skill in handling finances and keeping records were vital to our survival. Apart from these functions, she worked equally hard in the physical tasks such as picture framing and hanging.

Apart from our framing workshop, another department was added by taking on the sale of art materials, at first only to H.G. Glyde's students. Glyde had found that the supply of materials for his art students was an increasingly bothersome matter. He kept a small stock of paints and brushes that he sold to the students as needed. These materials were kept in the wine cellar of the large mansion that at the time housed the art department of the Provincial Institute of Technology and Art. The mansion, Coste House, was later used as a headquarters for different artistic groups on a co-operative basis. Painters, musicians, potters, weavers, theatrical and dance groups all found

accommodation under one roof, resulting in the formation of the Calgary Allied Arts Foundation.

While Coste House was the domain of the Institute's art department, a cigar box contained the proceeds from Glyde's sales and was used to replenish stock as necessary. When Glyde suggested that I take over the job of furnishing and selling these materials, we thus added another dimension to our enterprise. It soon grew into an important part of our operations, contributing materially to our gross earnings. Through Mr. Glyde's good offices we also started to furnish all the needs of the Banff School of Fine Arts and to some extent, the University of Alberta in Edmonton, besides catering to an increasing retail trade in the city. We had our sign amended to include "Artists' Colourman."

In the meantime our art collection gradually expanded. A.Y. Jackson occasionally sent us bundles of 10½ × 13½″ sketches. I paid him thirty-five dollars apiece and at first they were sold framed for only sixty dollars. Even so it required a lot of hard work and persuasion to find customers. Our standard sales pitch included the assurance that they represented a very good investment, which has been amply witnessed by today's prices.

I made one or two trips to the East with the object of adding more artists to our growing list and was always received with kindness and sympathy. Goodridge Roberts became a regular contributor and others like Stanley Cosgrove, the Coghill Howarths, and A.J. Casson soon added richness to the displays we could offer.

I had also been to see Thoreau MacDonald in his old home in Thornhill where he showed me a number of exquisite sketches by his father, J.E.H. MacDonald, and allowed me to buy one for a very small price. Unfortunately I was not in a position to buy many paintings, much as I longed to do so.

Many greatly gifted local artists contributed to our exhibitions: Maxwell Bates, Luke Lindoe, Janet Mitchell, and Wesley Irwin, to name a few.

Mr. Cummings, our landlord, had by now made further progress with the renovation of his building and one day told me I could have a larger space adjoining the law firm but separated from it by a corridor. Here we enjoyed a comparatively large area illuminated by two skylights and walls unobstructed by windows.

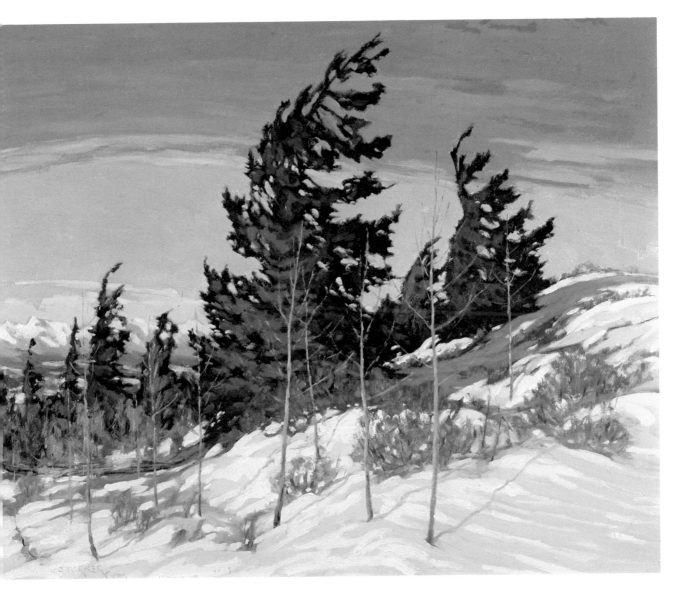

Chinook, 1946
24 × 30″ oil on masonite
Private Collection

It was now possible to have one-man shows and special exhibitions to which we invited prospective patrons by printed invitation cards. We felt that at last we were creeping toward our intended goal. Another advantage was that picture frame moldings were increasingly becoming more available, and our skill in framing had also rapidly improved.

Mr. Cummings still thought our enterprise had little chance of survival. When I asked him if he would grant me a lease on the new quarters he refused because he expected we would be broke in a few months. He was a man with a very keen business sense. He would appear on the first day of each month and hand me a note that said, "Rent, $150.00." I made a practice of having a cheque ready to hand him in return. It became quite an amusing game.

By now large oil firms were opening impressive offices in the city, consequent upon the oil boom of the 1950s. This afforded new possibilities for sales; the oil companies spared no expense in the elegance with which they furnished and equipped their premises. But in many instances their choice of pictures was left to someone with little discrimination, or forgotten entirely.

It was sometimes an interesting experience to call upon the chief executive officer of one of these firms. It was usually necessary to run the gauntlet of various ornamental female secretaries before making my way over deep pile carpet and among philodendron plants to reach the inner sanctum.

Here, in surroundings befitting an eastern potentate, the head man, probably in shirt sleeves, reclined in a padded chair and supported his feet on an acre of mahogany desk. He would probably be chatting on the telephone in an intimate fashion with his counterpart in Dallas, Texas, and maybe confirming some arrangement involving several million dollars for a pipeline. Having dealt with such matters with complete casualness, he would then turn his attention to me.

I would suggest the further embellishment of his surroundings by the purchase of a painting. Examining the picture he might ask, "Is it hand done?" Upon being assured of this, his next question would be the price—perhaps sixty dollars.

"*Sixty dollars* for a picture?" he would reply incredulously. "Gee, it must be some picture to fetch that much!"

With a substantial collection and a larger place to display them, we had an idea for the Canadian Art Collectors' Club. This was a plan whereby for ten dollars a month, a customer was entitled to choose any painting to hang in their home or office for that period. The painting could be exchanged for another each month for a year upon payment of the same amount. The total sum of $120 was placed to their credit in full for the purchase of any painting or paintings they selected to own.

This gave an opportunity to form a basis for ultimate choice and the convenience of buying on an instalment plan. In the meantime we had the advantage of the accumulated subscriptions to keep our bank account looking more robust, besides the fact that each member represented a sale in due course.

The Canadian Art Collectors' Club worked to everyone's satisfaction and resulted in quite a large number of sales that might otherwise never have been effected. It proved of particular benefit in connection with business firms who required several pictures each month to decorate their offices and who paid a correspondingly higher fee.

One day we had a visit from a young man who, following war service in the Navy, had used his post-war benefits to take a course at the Ontario College of Art, where he had developed a remarkable skill as a portraitist. His name was Winston Elliott. Now returned to his native province, he was looking about for a means of applying his talent. Our skylighted gallery provided an excellent studio and we were soon able to secure several commissions, which he executed to the complete satisfaction of his sitters. Later, he conducted evening classes in painting at the gallery.

We were finally invited by Mr. Cummings to occupy ground-floor space that had become vacant and had the advantage of a large show window. We moved the gallery downstairs but retained the upstairs premises for our framing department and for a studio.

We now had the valuable help of a picture framer, Fred Reeves, who worked long and cheerfully in return for a salary so small that his labor almost amounted to a donation. Elliott, too, applied himself to our assistance for, apart from painting, he was equally capable as a carpenter and constructed cupboards, shelves, and various fixtures that would otherwise have been costly. All operations proceeded in an atmosphere of extreme congeniality, each participant always finding in

Calgary, 1977
10½ × 13½'' oil on wood
Private Collection

others some source of amusement. Fred's laughter was particularly infectious.

The Provincial Institute of Technology and Art had regained its former premises from the R.C.A.F. and moved the various departments back to their original home, including Glyde's greatly increased group of art students. There we were given a special room to continue our art supply store. One of the students acted as our storekeeper during specified periods of the day and evenings when night classes were held.

By then we had quite an impressive inventory of art supplies and a fairly substantial turnover. In addition, we stocked books and publications relating to art in our gallery premises. We also sold Penguin books, the first in Calgary to carry this popular line of pocket-books, and enjoyed a remarkable turnover before they became more widely available.

We continued our practice of having one-man shows and special exhibitions. Our very first show in our upstairs gallery featured the work of Maxwell Bates, who had just recently returned to Calgary following his experiences as a prisoner of war in Germany for five years after the Dunkirk evacuation. On one occasion we were able to present an exhibition of paintings by David Milne, but when the show ended we had not sold a single item other than a small oil, which we bought for ourselves.

H.G. Glyde relinquished his position as head of the art department at the Provincial Institute of Art and Technology to accept a similar appointment at the University of Alberta in Edmonton. He was succeeded by J.W.G. (Jock) Macdonald, who became one of our dearest friends. Macdonald emanated a charm that endeared him equally to all and helped to inspire his students with the greatest enthusiasm. It was a great loss to Calgary when he, in turn, left to take a position with the Ontario College of Art. There he was instrumental in establishing the Painters Eleven group, which included some of his most gifted students such as Harold Town, William Ronald, and others who later enjoyed the fruits of his influence and have since risen to prominence in their profession.

From a city of about eighty thousand inhabitants at the end of the war, Calgary expanded at an amazing rate mainly due to the development of the petroleum industry. Old buildings disappeared and skyscrapers took their place with such rapidity that they appeared almost as if by magic. Growth of the city was not confined to the business

section; the residential areas spread into what had lately been the countryside to accommodate the increasing population. Places we had enjoyed for country hikes were now being bulldozed and turned into streets, which were lined with houses occupied almost before the last nail was driven. Sadly, we watched the natural beauty of the landscape suddenly change to a characterless suburban jungle, still further marred by shopping centres to cater to the requirements of residents now far removed from the downtown market-places.

We had survived the first few most difficult years and with the economic boom, conditions gradually improved. Our first bit of really good luck stabilized what had so far been a highly speculative undertaking.

Among the artists whose work we handled was A.C. Leighton, a highly competent painter who decided to appoint us as his sole agent. As a result he placed in our hands his entire stock of pictures totalling well over one hundred pieces. They ranged in price from about a hundred dollars for small watercolors to five or six hundred dollars for larger oil canvasses.

One evening just before closing time, a man I had not previously met came in and selected seven or eight of Leighton's paintings, saying he would send for them to be picked up and would mail a cheque. He was a Mr. Baron, owner of a large tractor company. We were naturally jubilant at making such a substantial sale and went home leaving the chosen group of paintings stacked against the end wall of the gallery. The same evening a water main broke in the street and water flowed in under the gallery door. Fortunately it did not quite reach Mr. Baron's pictures, stopping within a few feet of them, otherwise they would have been ruined.

Not very long after making this purchase, Mr. Baron returned and said he would like to buy any other paintings by Leighton we might have. The remainder still totalled over one hundred items. Mr. Baron bought them all. Such a windfall was more than we could have imagined in our wildest dreams.

Leighton was in England at the time and had arranged that I should deposit any earnings to his account in a local bank. I sent him a copy of the deposit slip for Mr. Baron's very large cheque. His reaction, of course, was one of delighted surprise. Long afterward, when he had returned and the income tax department learned of his financial gain, he looked upon the matter with less pleasure.

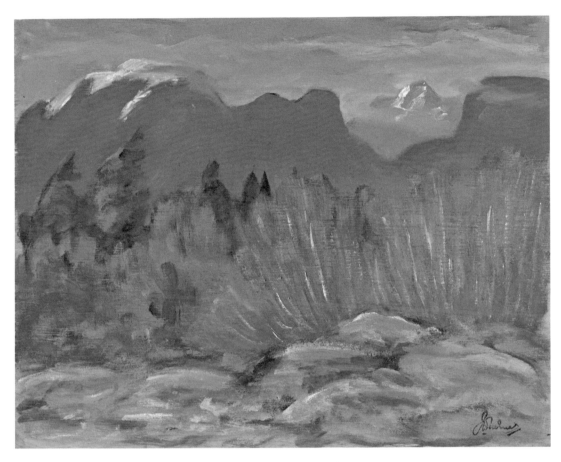

B.C. Sketch No. 1, 1976
10½ × 13½″ oil on wood
Collection of Grace Turner

It seemed unlikely that we should ever enjoy such a transaction again, but our stars must have been favorable. We received a letter from a Mr. Morse in Victoria, B.C., informing us that he had been visited by a friend from Calgary who had given him a satisfactory account of our gallery. Mr. Morse said he had been stricken with a severe illness, and wanted to dispose of part of his collection of English watercolors of the eighteenth and nineteenth centuries. He thought we might be able to sell them for him.

I went to Victoria to interview Mr. Morse and found that he owned a truly fine collection, accumulated over a lifetime. The artists included J.M.W. Turner, Richard Parks Bonington, David Cox, Anthony van Dyke Copley Fielding and a great many others of considerable reknown. Among the more unique items were several small pieces by John Ruskin and one H.S. Palmer of particular charm.

I returned with a small number of works to use as an experiment to see if I could sell them. Our benefactor, Mr. Baron, promptly bought them. Mr. Morse was gratified and sent me a further group of his pictures with the same result.

Finally I had a communication saying that, instead of Mr. Morse succumbing to his illness, his wife had died suddenly from a heart attack and that he was being cared for by his niece. In view of these unhappy circumstances the remainder of his collection was turned over to us and sold to the same purchaser.

This transaction involved a large amount of money and was naturally of great benefit to us, but we were sad that it should have arisen as the result of another's misfortune. It would be interesting to know how much greater the value of these paintings are today in view of the current increase in art prices.

As a result of similar rising prices for real estate, Mr. Cummings sold his building and we soon got notice of a staggering increase in our rent. It was necessary to move out and find a place at a more reasonable cost. In the meantime, Fred Reeves decided to move to the coast and we found it unprofitable to tie up a considerable amount of capital in stocks of picture frame moldings. We made arrangements with another local framer to make our frames at a favorable discount, which also made it unnecessary to have more than minimal workshop space. At this time Winston Elliott found a position at the Calgary Allied Arts Foundation

as supervisor-cum-caretaker, which provided him with living quarters and studio space.

Grace and I were thus on our own when the time to move came again. A new site was located on 17 Avenue, a thoroughfare that has since become the main locale for art galleries, now quite numerous.

Art appreciation was slow in its development generally speaking and we had many amusing experiences. It was not uncommon for prospective customers to bring samples of their drapes, chesterfields, or rugs to select suitable decorative pictures combining the various hues for their newly built homes. Color was regarded as the only important factor in choosing a work of art.

Framing, also, was not confined to the embellishment of works of art but might challenge our skill when the object was a stuffed fish or a colored photograph of a prize cow. The most vexing of all were the petit-points. These had to be stretched on cardboard so that every thread was in perfect alignment, and there was always a long conference as to the choice of molding. The samples were soon scattered all over the premises and then subsequently sorted out and replaced in their proper order.

We latterly found an even more satisfactory solution to the framing problem, which was introduced to us by the manufacturing firm with whom we dealt. They provided us with a simple order form. We listed the sizes and details of frames required and mailed the form to them at the end of each day. They promptly made up the frames and shipped them back allowing us an ample margin of profit. We also carried a stock of standard sizes that could be supplied to our customers immediately.

Of all the painters represented in our gallery the work of Walter J. Phillips was among the most appreciated. His magnificent watercolor technique and his choice of subject matter did not demand a sophisticated eye to recognize its merit or appeal. We had become his sole agents locally although he sold his work in Winnipeg, where he had originally settled and lived for many years after coming to Canada from his native England. There was also considerable demand for his paintings in eastern Canada.

Some of Phillips's most brilliant work was reflected in his color wood-block prints and wood engravings, which he executed with a skill probably unmatched in North America. He was a man for whom we felt

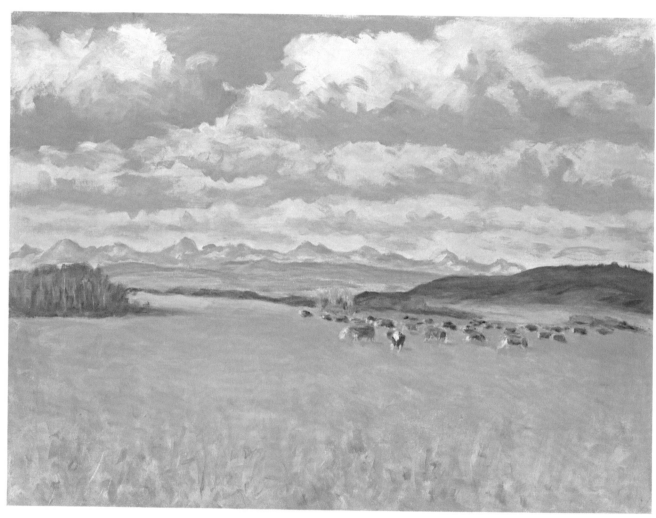

Cattle in Spring, 1980
24 × 32″ oil on canvas
Collection of Grace Turner

great fondness and respect. He dressed with immaculate care, giving more the appearance of the head of some large business firm rather than that of an artist. No attempt was made by him to create an image by the adoption of any eccentricity in looks or manner that sometimes marks those of lesser accomplishment. The loss of his eyesight at the zenith of his artistic career was a tremendous tragedy.

After his death we suggested to the National Gallery that they sponsor a retrospective exhibition of his work, a suitable tribute to his important contribution to Canadian art, but they were unsympathetic to the idea, even though the same has been done for others who, it seemed to me, were less worthy.

Two other artists of outstanding ability were Belmore Browne and his son George. Belmore's paintings of our mountain landscapes were equal to any of this subject ever executed. Having lived in Banff for some time, he had an intimate knowledge and love of the environment, and recorded the real spirit and character of the Rocky Mountain scenes in every mood and season.

George specialized in birds and other wildlife of the region with equal mastery. His landscape settings were a reflection of the skill inherited from his father. The personalities of both men and their wives were warm and full of humor, and were probably enhanced by lives happily devoted to an occupation that was largely its own reward.

In speaking of personalities, we found that what is said above might be generally applied to all artists, who also had their own individual differences. A.Y. Jackson had a simple homespun quality that made him at home wherever and with whomever he happened to be. He was loved not only for his art but for himself as a man, across the length and breadth of Canada.

Arthur Lismer, with his somewhat high-pitched voice, seemed to be always bubbling with humor, which was accented by a peculiar absent-minded manner. His pipe might be found reposing on a newel post at the foot of the stairs leading up to his second-floor office, where he would be found surrounded by an untidy confusion. When he wanted to leave, he would be unable to find his hat or coat or over-shoes. Once, helping in the search for his overcoat, Grace found one hanging from a hook on the door. When she asked if it was his, he said, "No, it couldn't be mine – it's hanging up!"

A local artist, Roland Gissing was equally honest and forthright. He painted landscapes and said that if he painted as he wished, he would be unable to make a living. We had a customer who admired one of his mountain landscapes but was deterred from buying it because she wanted one "with a bit of snow on the mountain tops." We gave it back to the artist and asked him to arrange for a slight climatic change. Having done so, the customer was satisfied and the sale was completed.

By this time, the Provincial Institute of Technology and Art had increased its enrolment of students in proportion to the general expansion of the city, or rather, of the province. People were flocking in the wake of the huge oil development and consequent flourishing times. Large new buildings were erected on the campus to accommodate the increasing number of students, dwarfing the small original but handsome structure, which, once a landmark, now seemed lost among the impressive new ones.

From the basis of our art materials shop, we were invited to take on the operation of the Institute Book Store to fill the requirements of students in all departments, not only with textbooks, but an assortment of needs from drafting and surveying instruments to cooking utensils. We obtained whatever was necessary for instruction by the direction of the various heads of departments.

A clerk-manager was hired on a full-time basis, and we were very soon heavily engaged in this rapidly expanding branch of our activities. Indeed, it was so demanding of our time and attention in the process of ordering and maintaining stocks, accounting, and so on that we were forced to relegate the art gallery to second place in our considerations. While it was satisfactory as a profitable business venture, it was evident that we would have to make a choice between it and the gallery. We could not handle both without sacrificing efficiency or largely increasing our staff.

As the art gallery had been our main and long-standing objective, and it had now reached a reasonable sound degree of establishment, we suggested that the Institute take over the book store as a department of its organization. The provincial government purchased our inventory and took on our staff as civil servants. Today it has a very large volume of business and has assumed something of the proportions of a supermarket, an interesting evolution from the cigar box in the wine cellar.

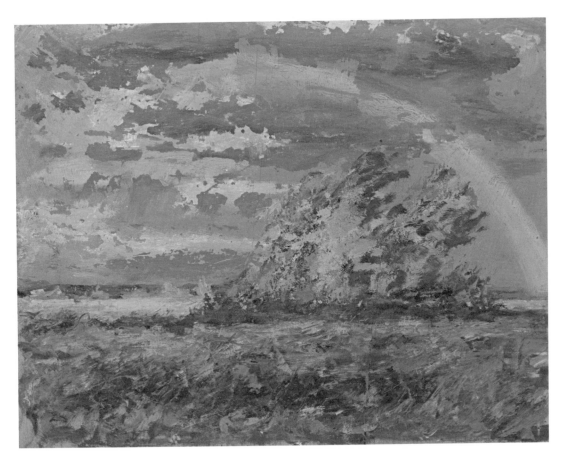

Rainbow at Sunfield, 1950
8 × 10″ oil on wood
Collection of Grace Turner

Upon the death of Belmore Browne, we were entrusted by his daughter, Miss Evelyn Browne of New Hampshire, Connecticut, with the disposal of all her father's remaining works. They comprised a considerable number of paintings, and quite a large portion of them were major canvasses. It was a magnificent collection and was purchased in its entirety by the late Eric L. Harvie for the Glenbow Foundation.

This organization, under Mr. Harvie's capable and far-seeing guidance, had acquired a tremendous collection of works of art, archeological artifacts, archivist material in the form of historic letters, books, and so forth, as well as ancient weapons, native Indian costumes, appurtenances, implements, and pottery. The entire immense collection was gifted by Mr. Harvie to the people of Alberta together with a very large sum of money to aid in its continuing growth. Today the Glenbow-Alberta Institute is a unique organization in Canada for the richness and variety of its possessions, and a worthy monument to the wisdom and generosity of its founder.

The premises we occupied were increasingly inadequate for our purpose, and we found ourselves working under a considerable handicap for this reason. In conversation with our bank manager I had sometimes jokingly said that I wished they would move out of their building, three blocks west of us on 17 Avenue, and let us have the bank for our gallery, which seemed admirably suited to our needs. Strangely enough, at the height of our difficulties he telephoned me to say they were moving to a new location and that I should apply at once to their present landlord for a lease. We did, and soon moved into the desired quarters, which had the advantages of a fire-proof storage vault, a large main floor space and an equally commodious basement, which could be used as a gallery area as well as adequate workshop accommodation.

We felt that in taking over a bank we had come a long way since the nine-by-twelve-foot office in the law firm. Now we had a comfortable lounging space in which to serve coffee to visitors and where previews to exhibitions could be held with facilities for refreshments.

During the twenty years from 1945 to 1965, we had established the gallery and brought it to its current respectable state of existence. We had enjoyed every day of the process, and made lasting friends with our artists and our customers. It had required the most strenuous efforts for both Grace and myself, now both much older and more subject to

fatigue. While the gallery was still a source of pleasure to us, it seemed a good time to give it up lest it should become a burden.

We had done what we set out to do to our own benefit and, I hope, somewhat to the benefit of others, and were now ready to call it a day. The gallery was therefore passed into the hands of others still possess-ing the vigor of youth and as yet continues to survive and, I hope, to prosper.

Having acquired a home and a studio on a small acreage outside of Calgary called Sunfield, my own chief desire was, at last, to paint.

The type style is Kennerley. Typeset by The Typeworks,
 Mayne Island, British Columbia.
Line drawings by John Davenall Turner.
Two-hundred-line screen separations by BK Trade Colour Separations Ltd.,
 Edmonton, Alberta.
Designed by Joanne Poon and edited by Katherine Koller Wensel
 of The University of Alberta Press.
Printed by Hignell Printing Ltd., Winnipeg, Manitoba.

John Davenall Turner's official Coat of Arms denoting cartoonist, painter,
 and writer, from the College of Heralds, London, England.